Produced on the occasion of the exhibition
THE BUDDY SYSTEM, March 20–April 24, 1999

DEITCH PROJECTS, 76 Grand Street, NYC 10013
TEL 212.343.7300 FAX 212.343.2954

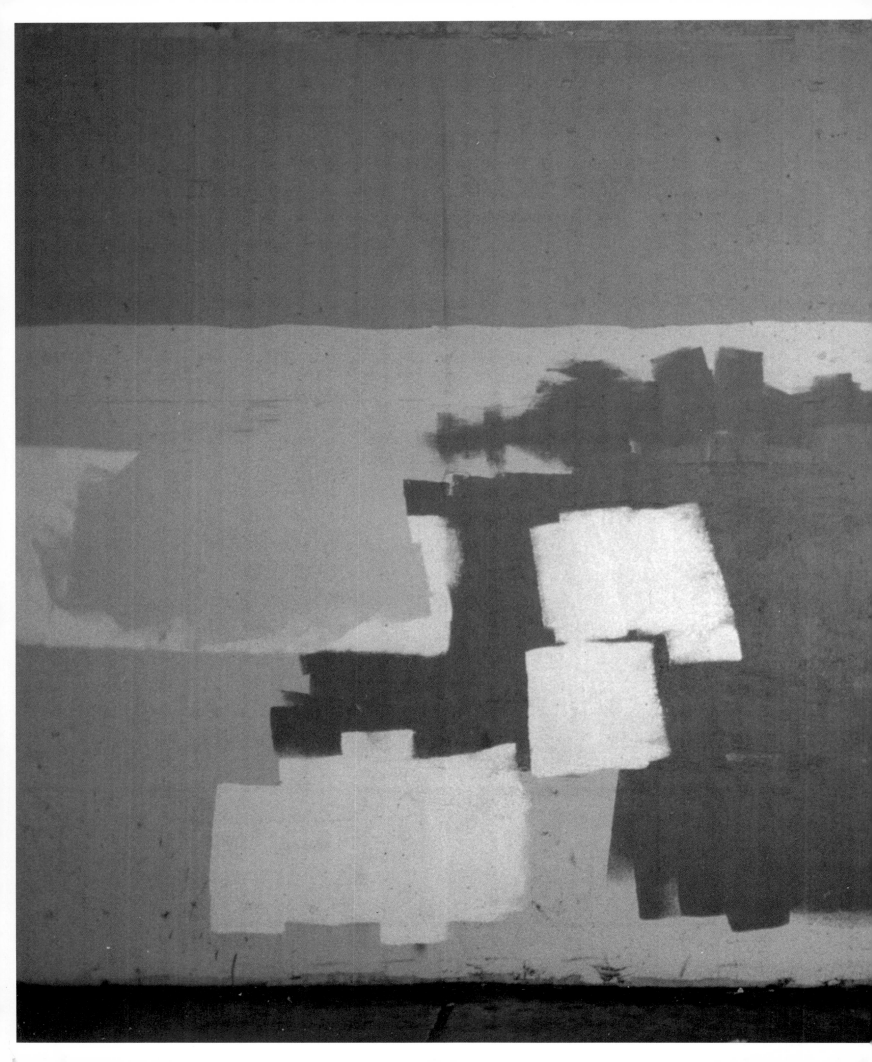

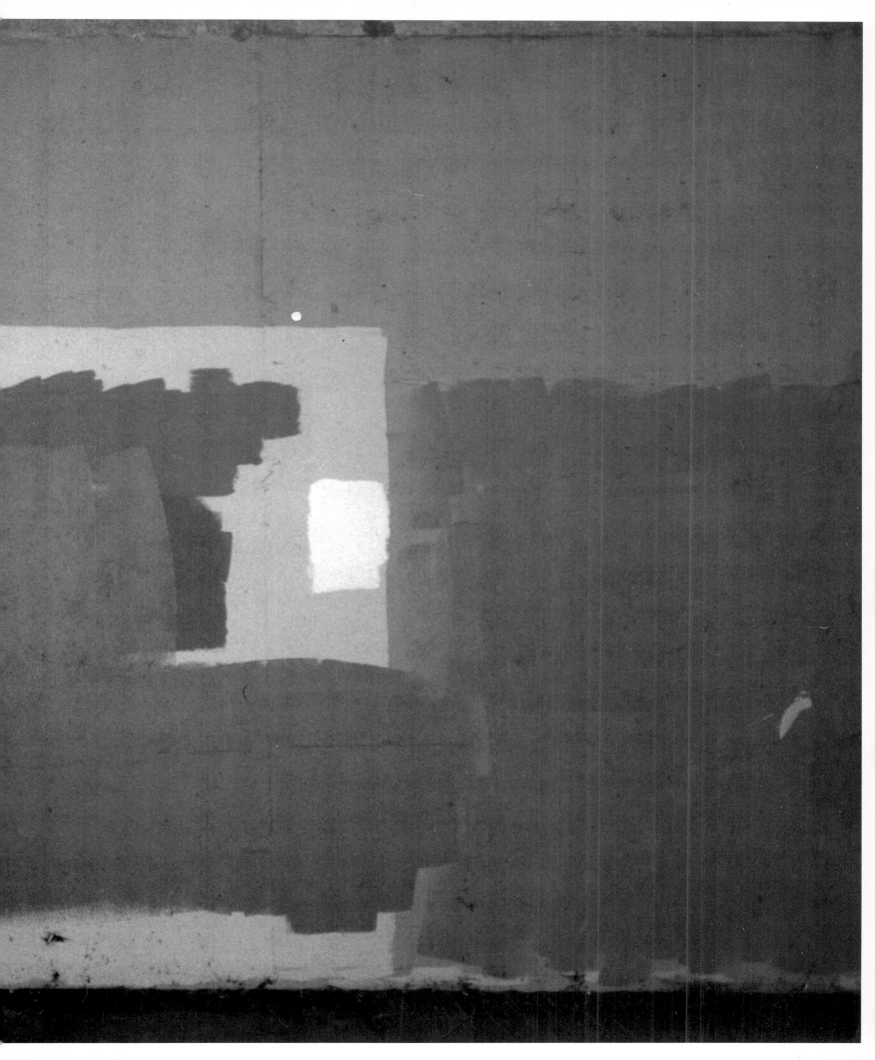

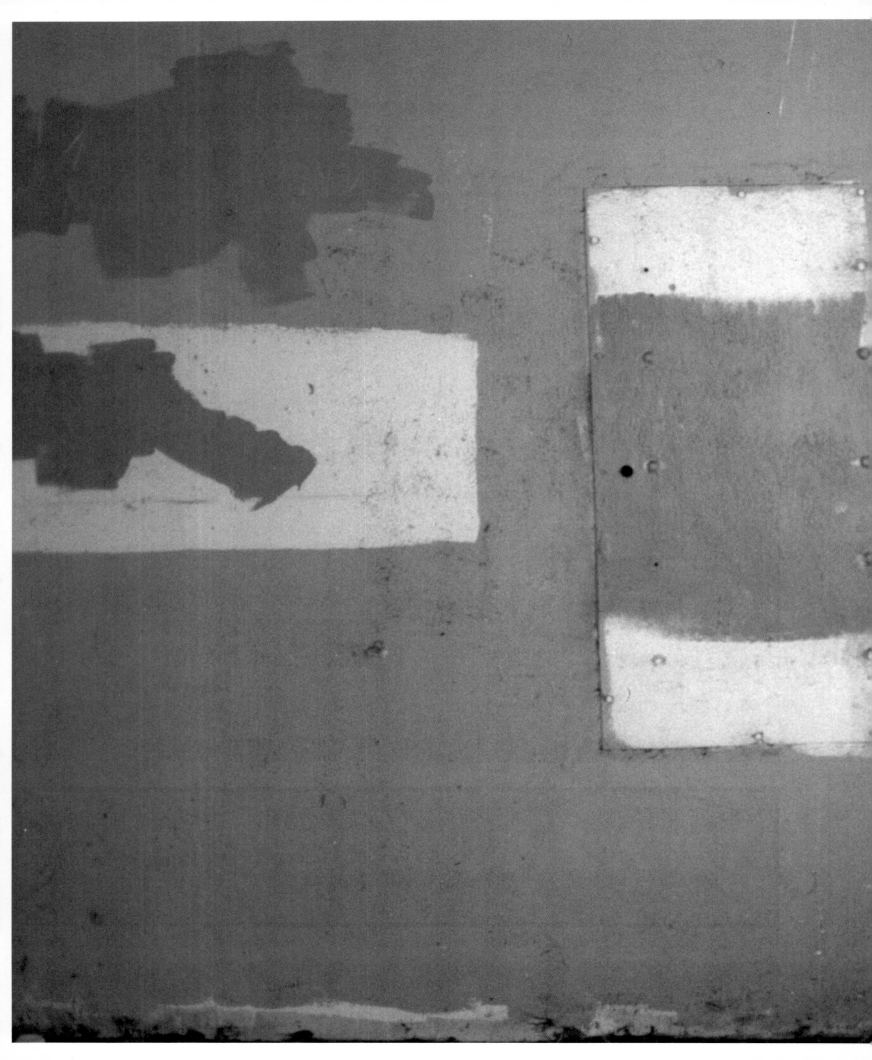

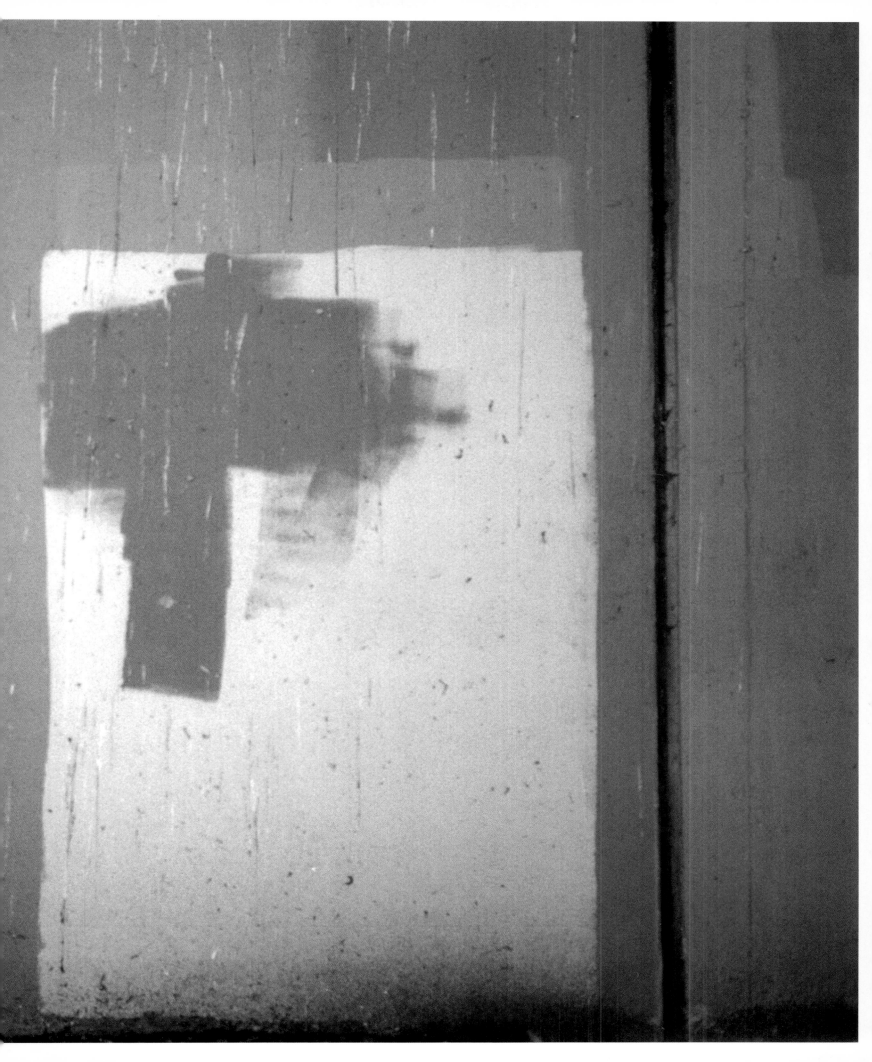

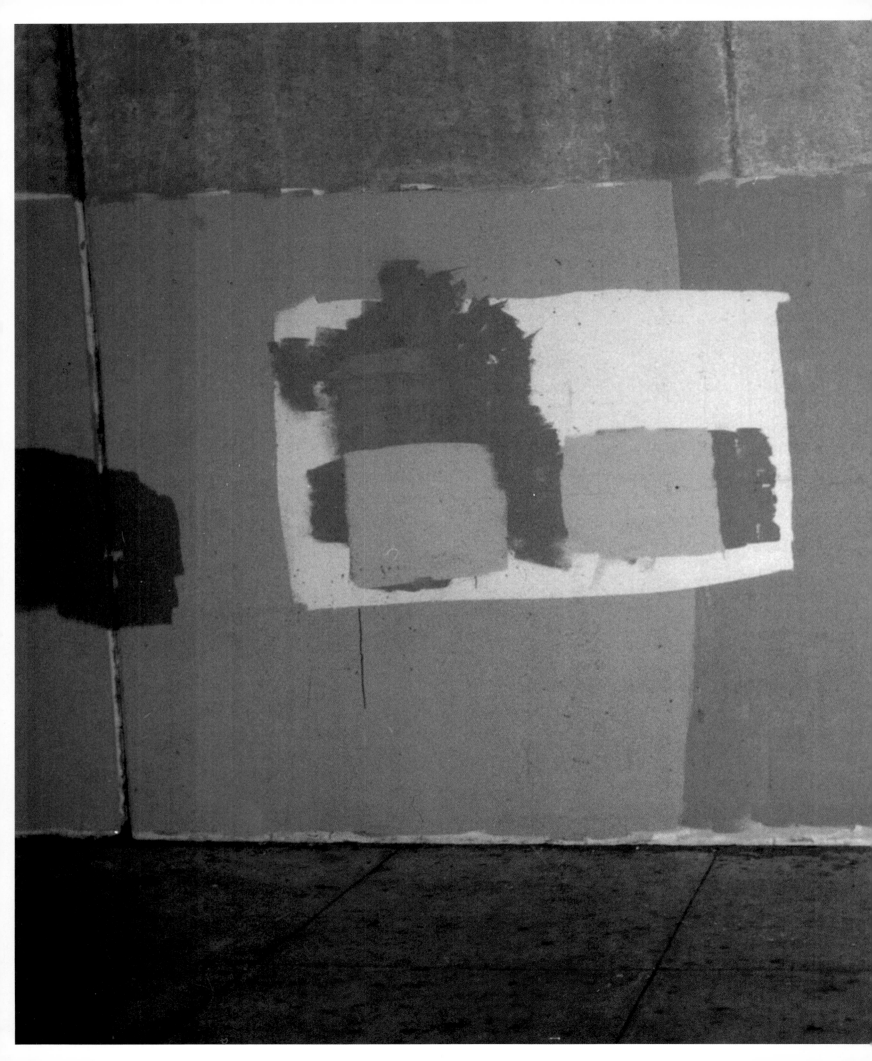

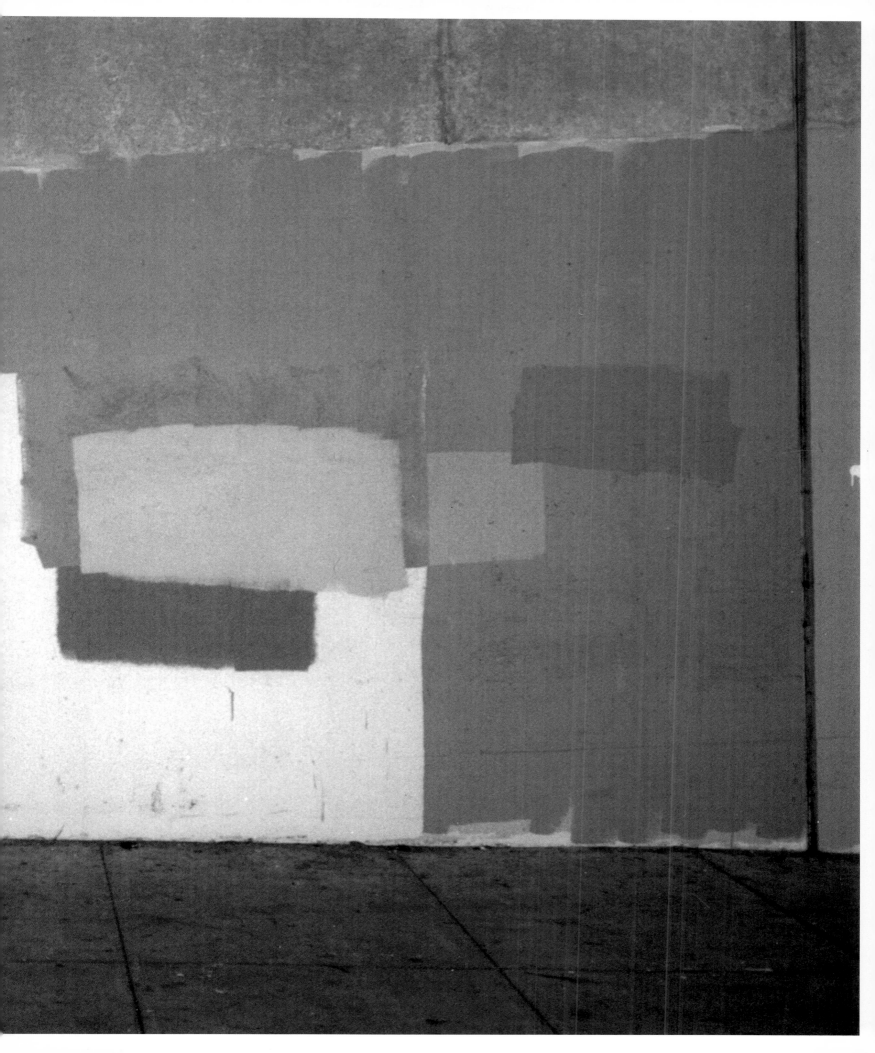

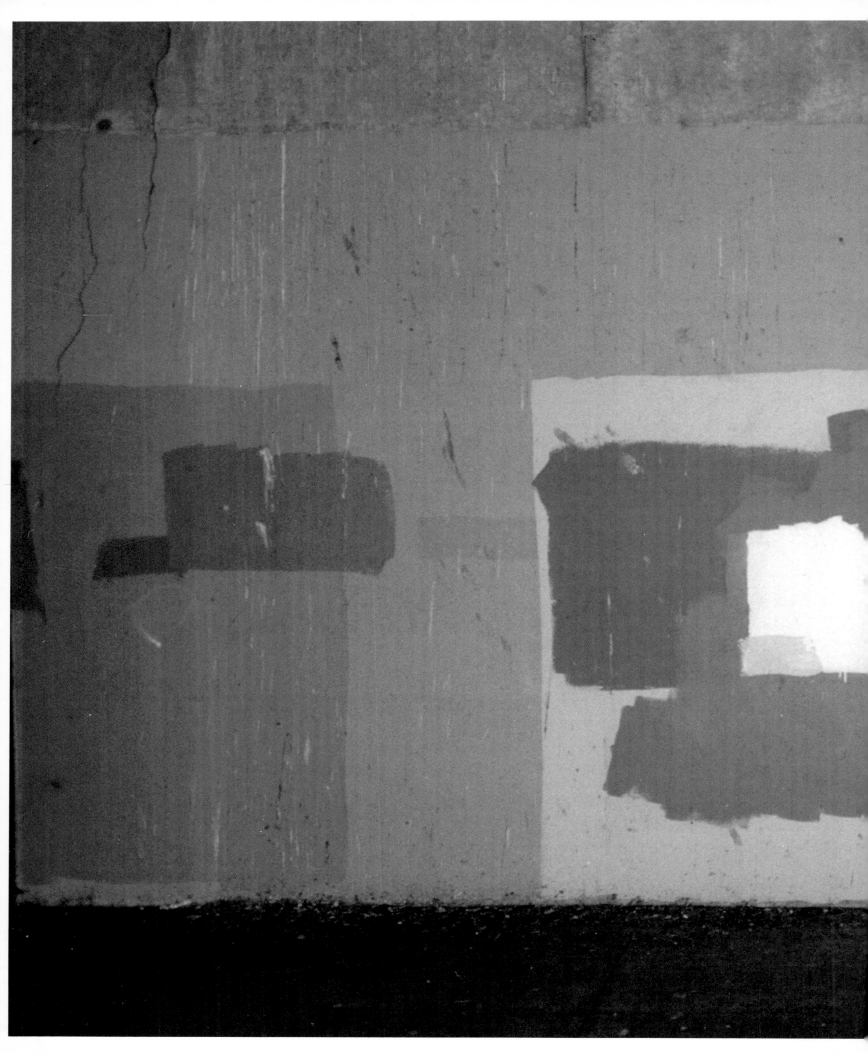

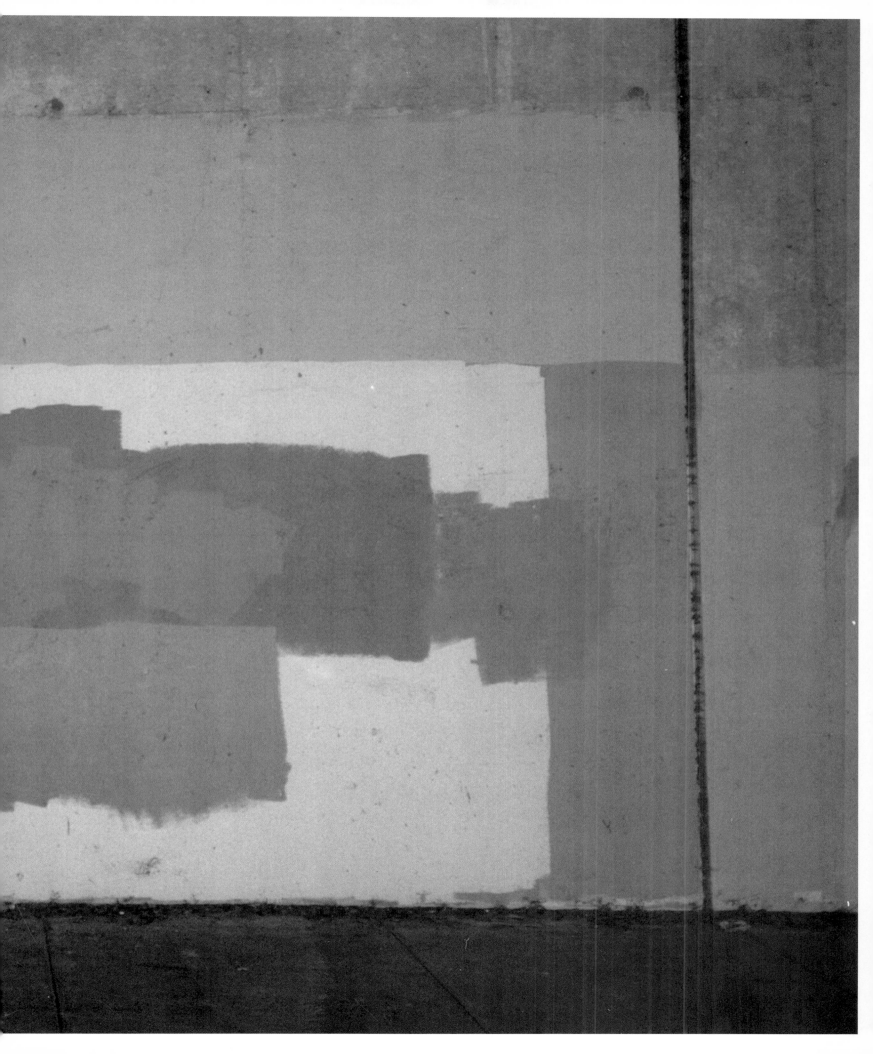

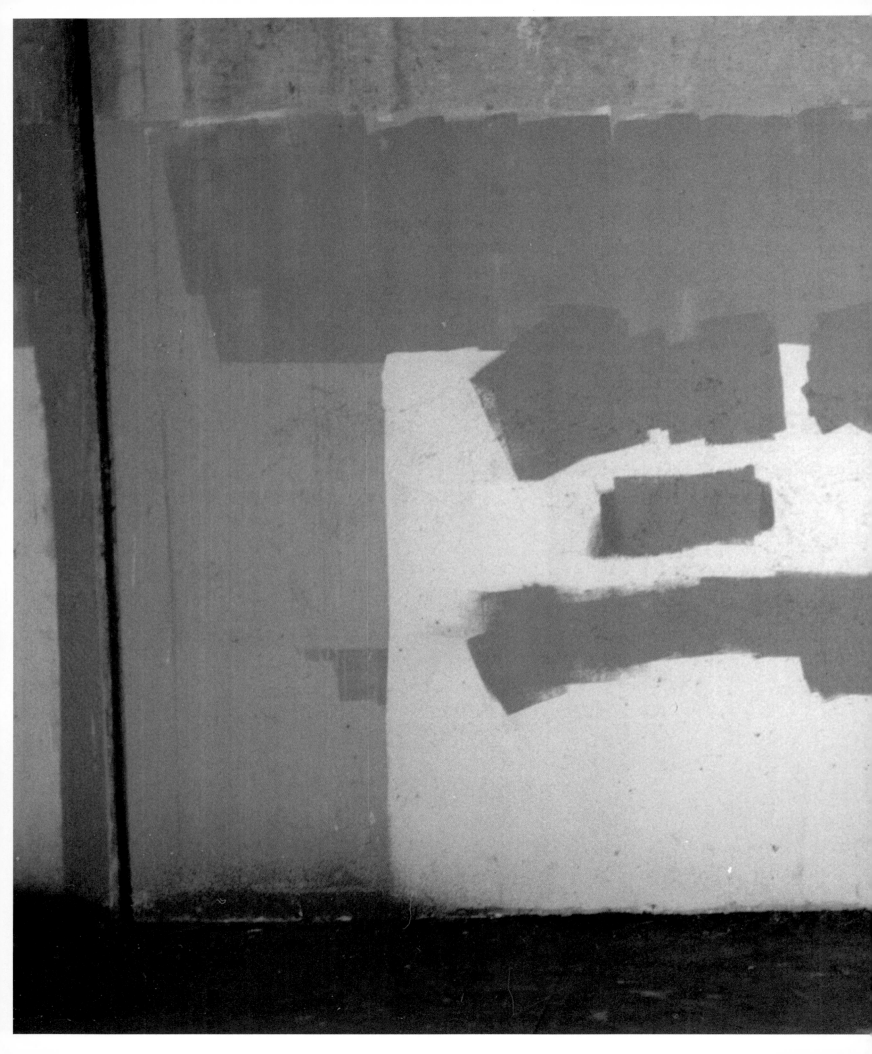

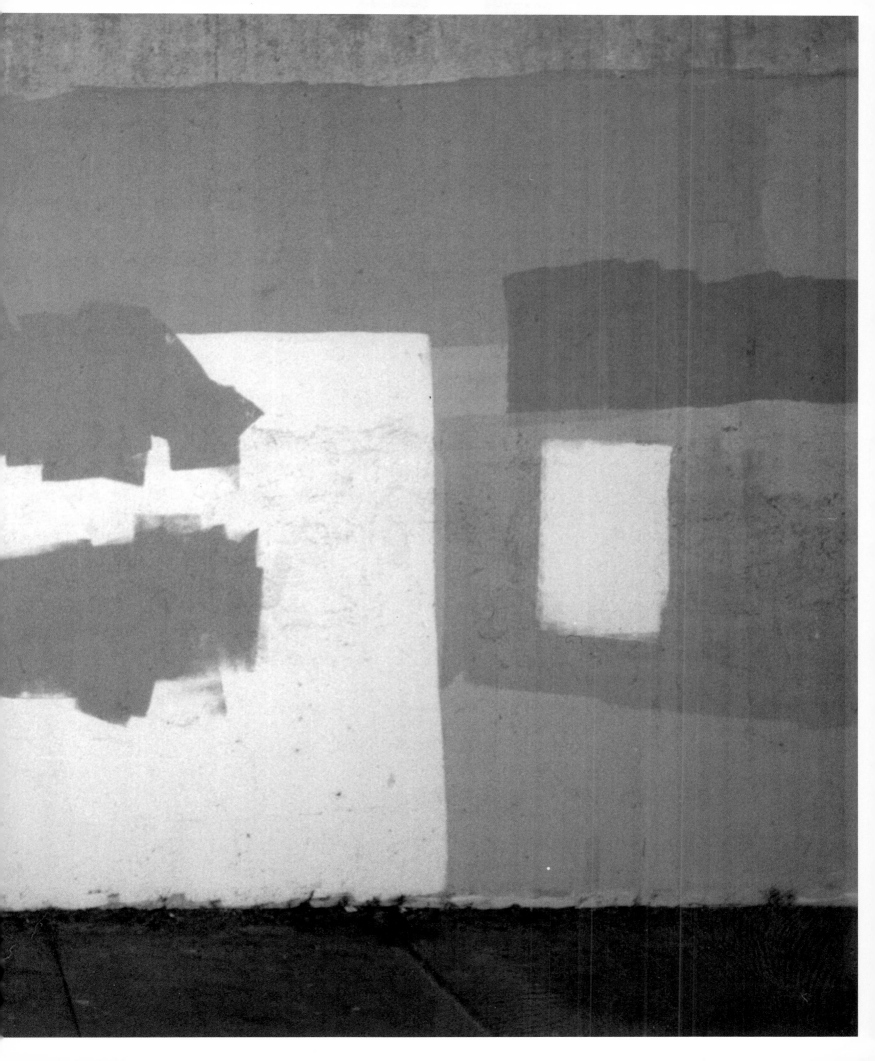

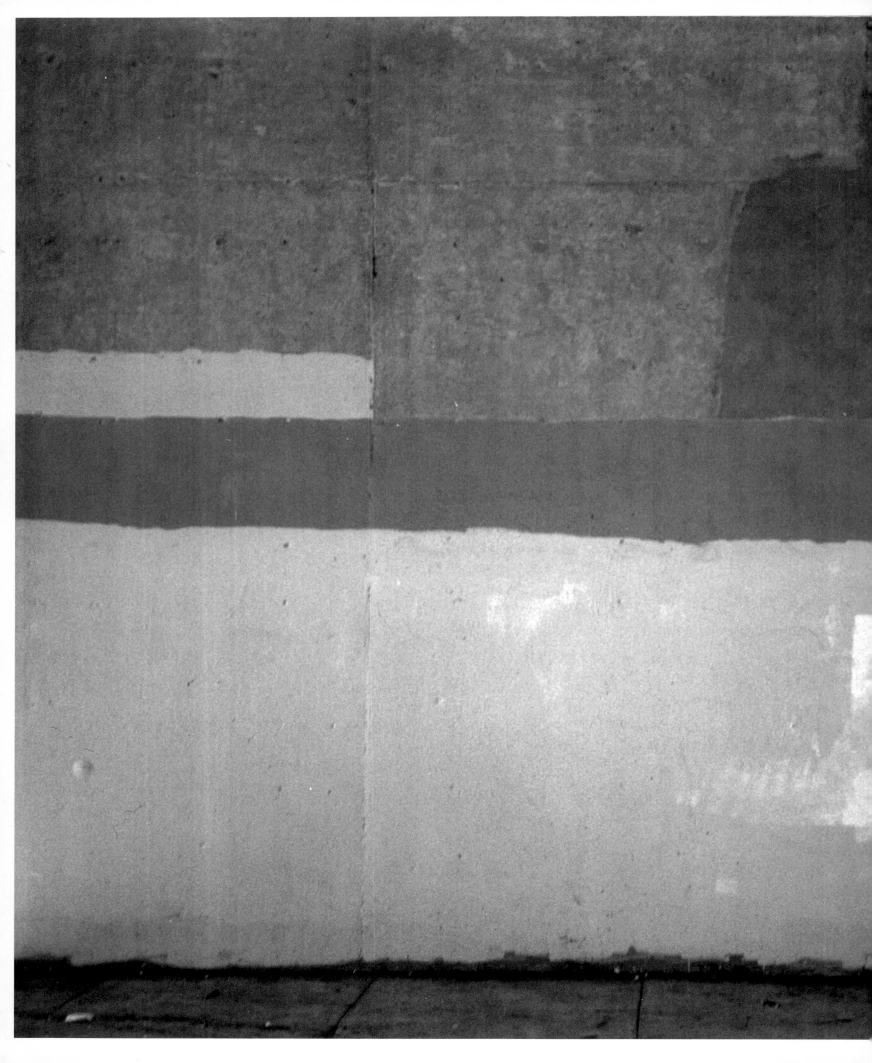

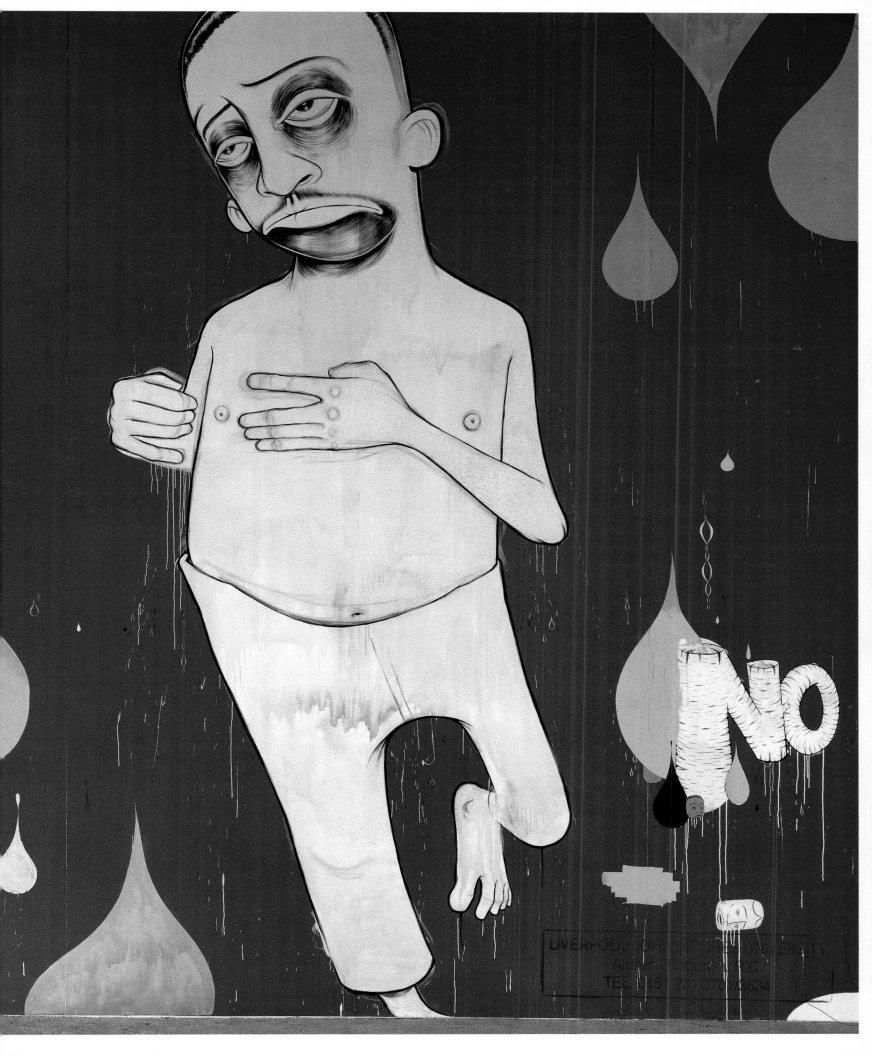

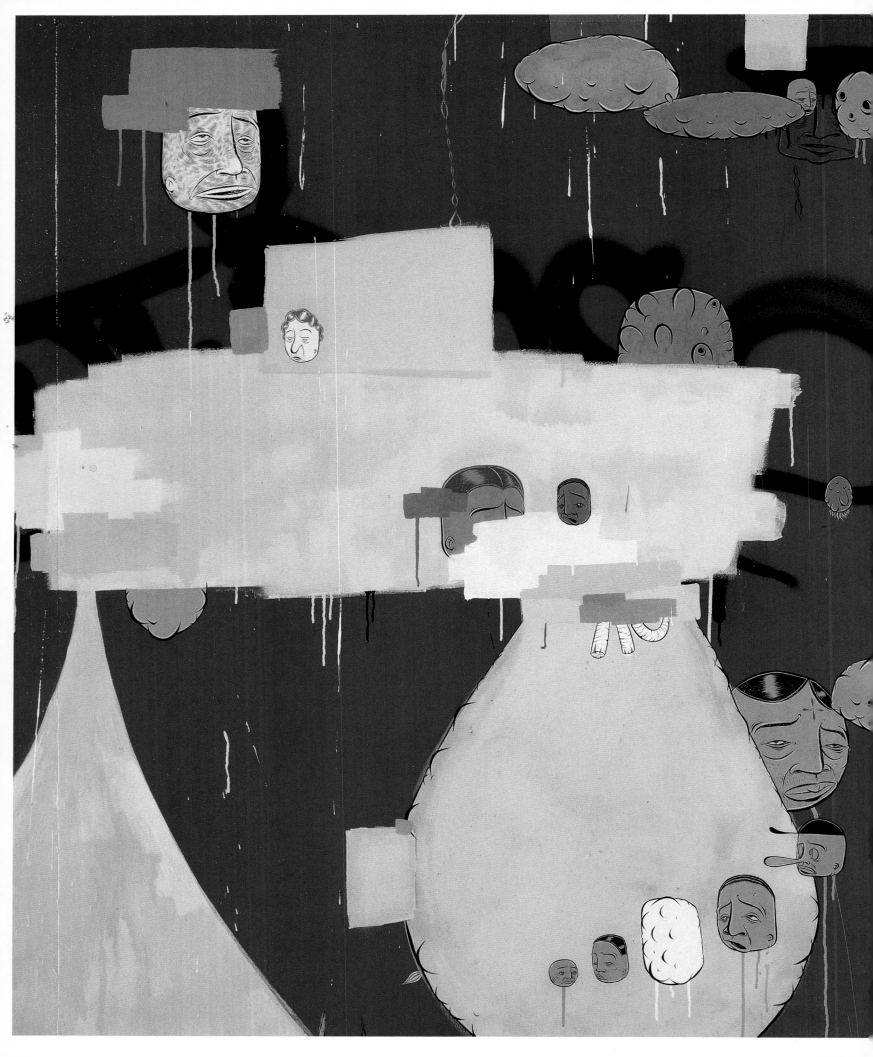

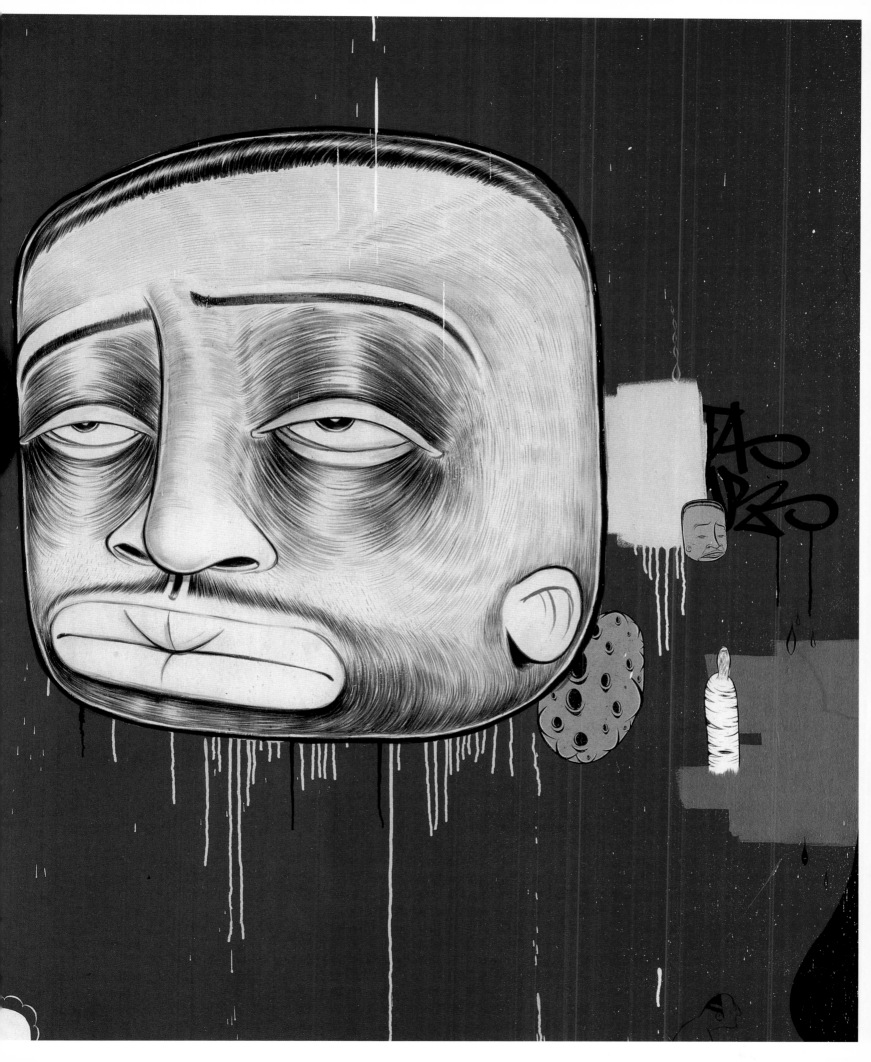

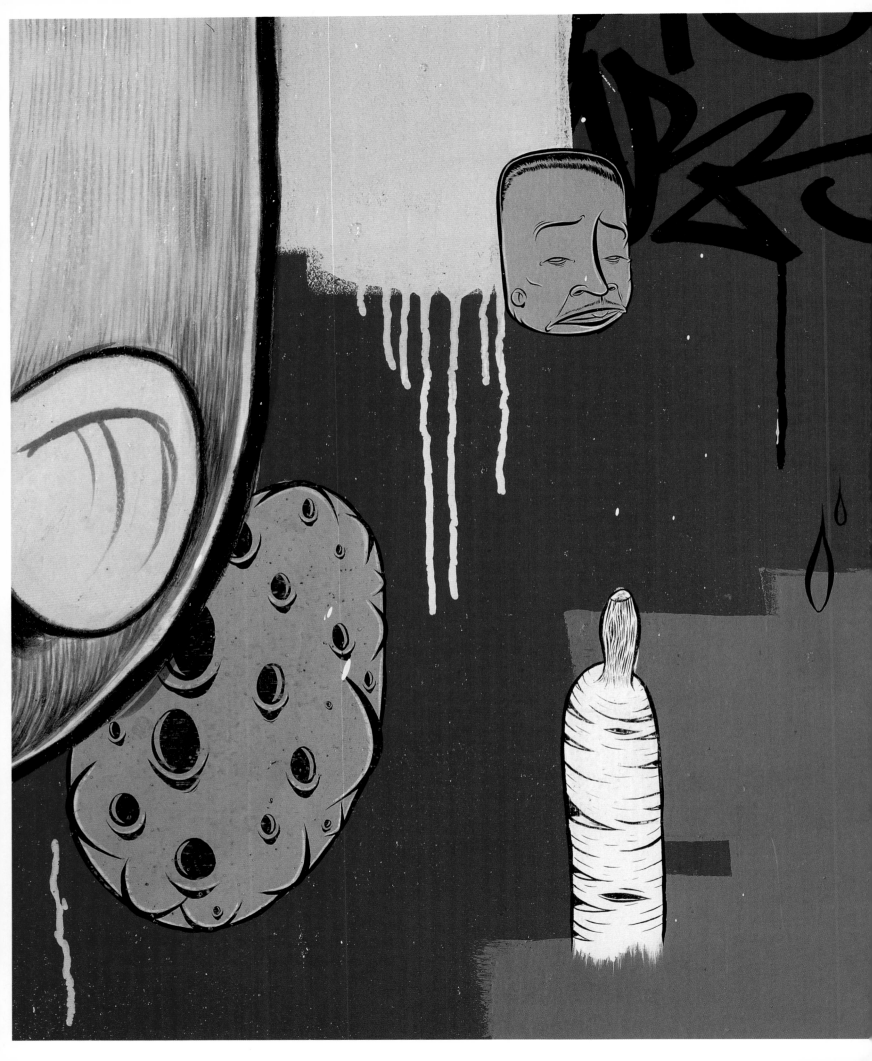

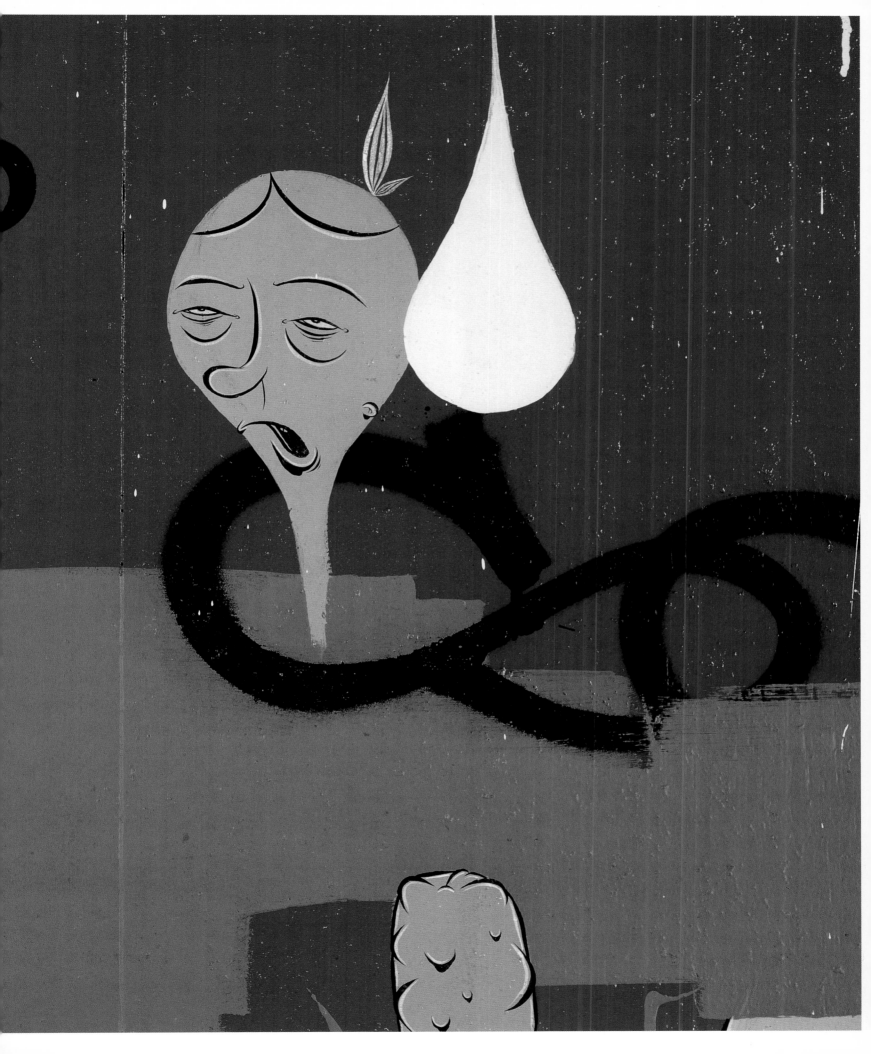

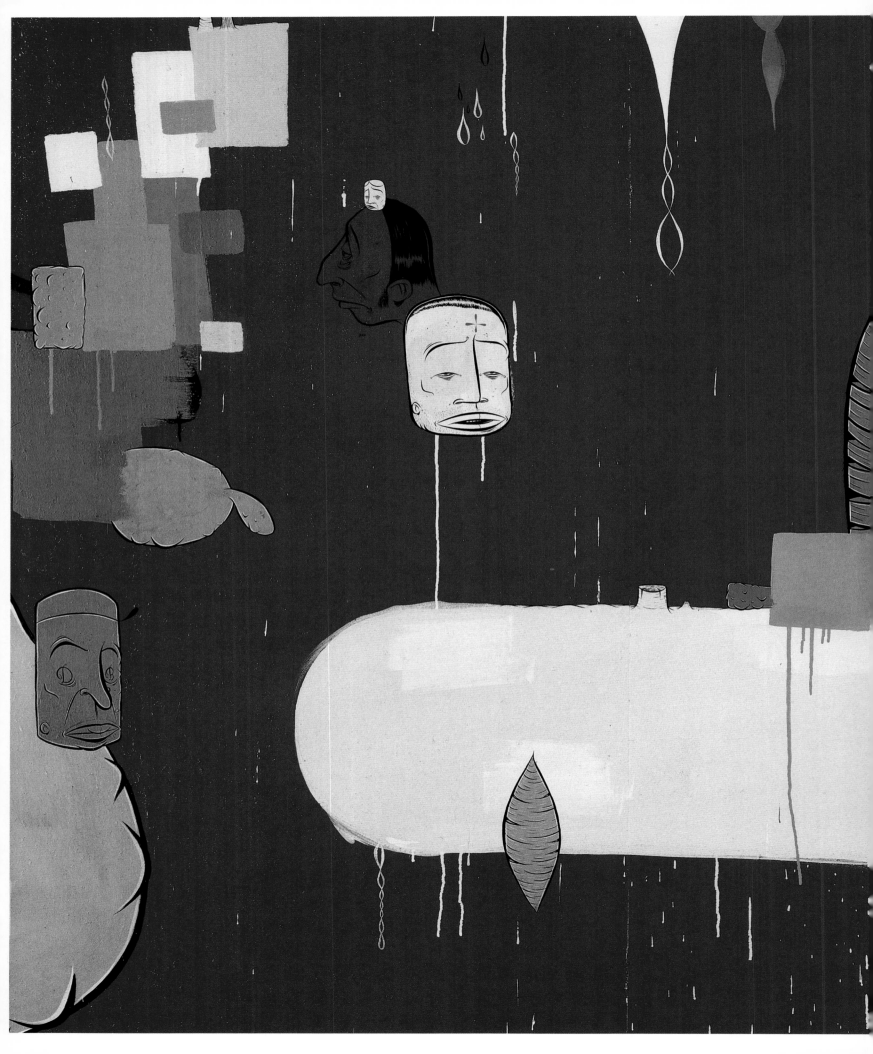

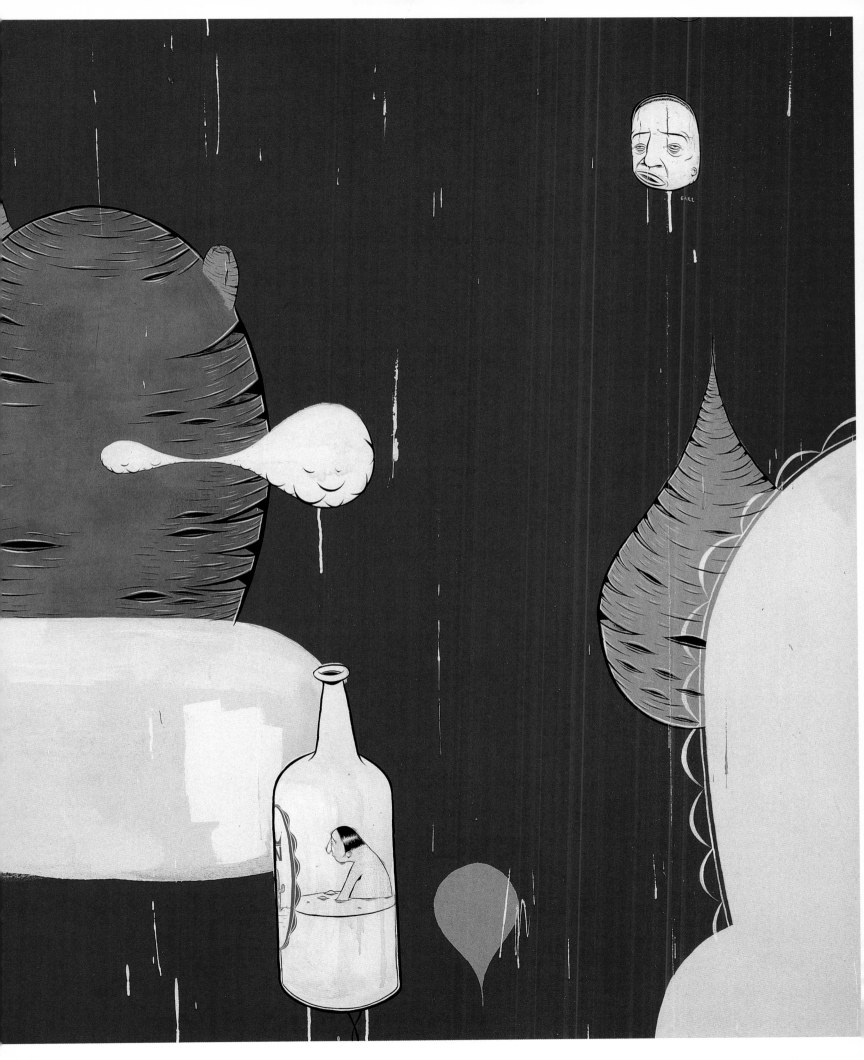

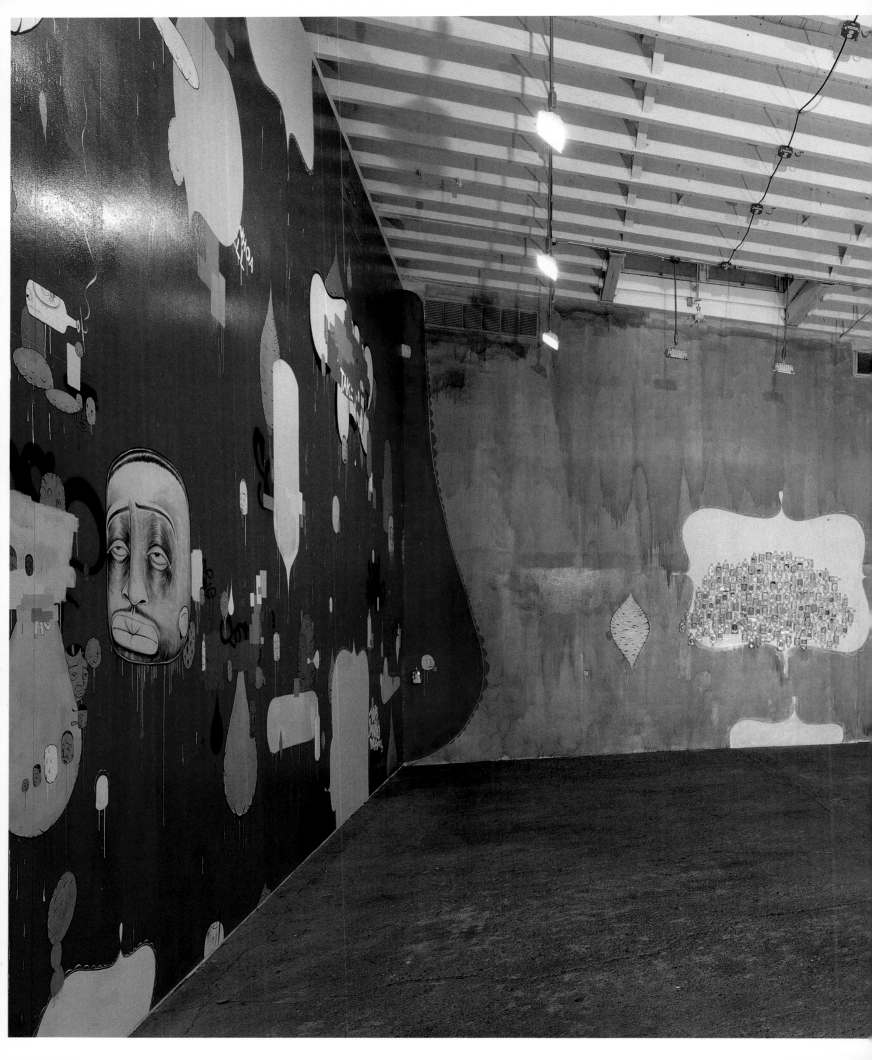

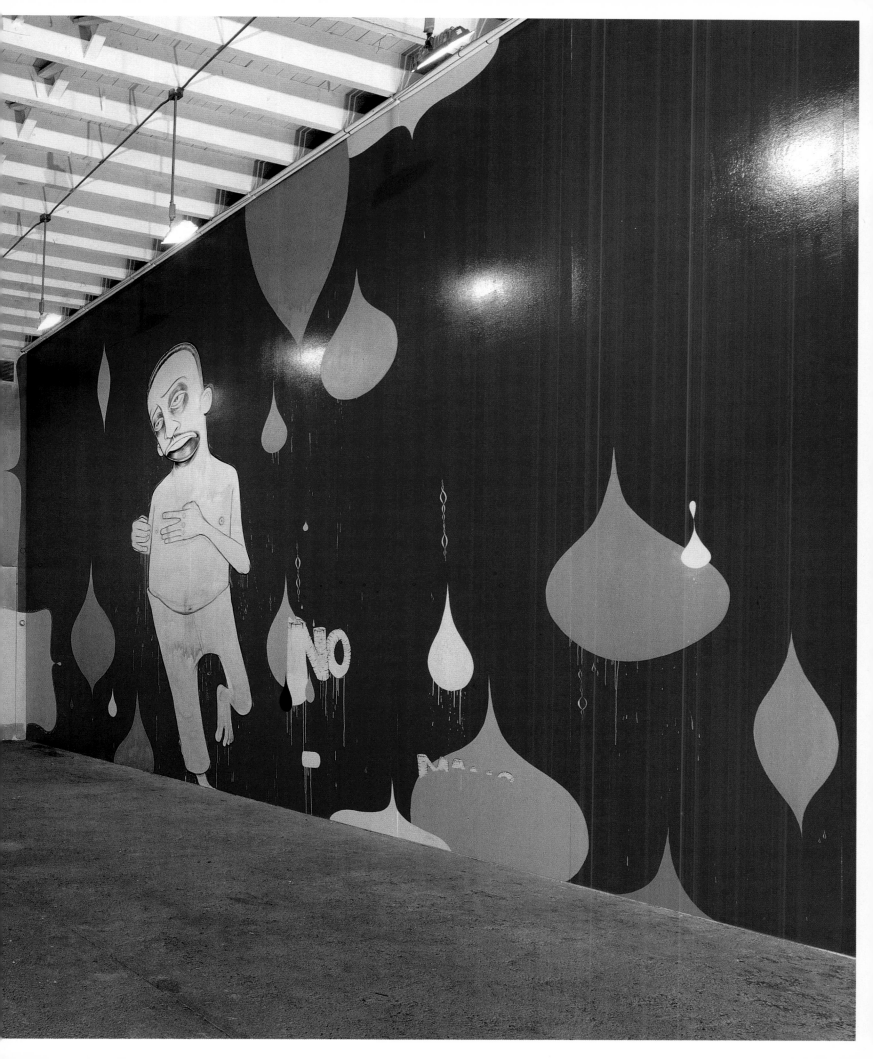

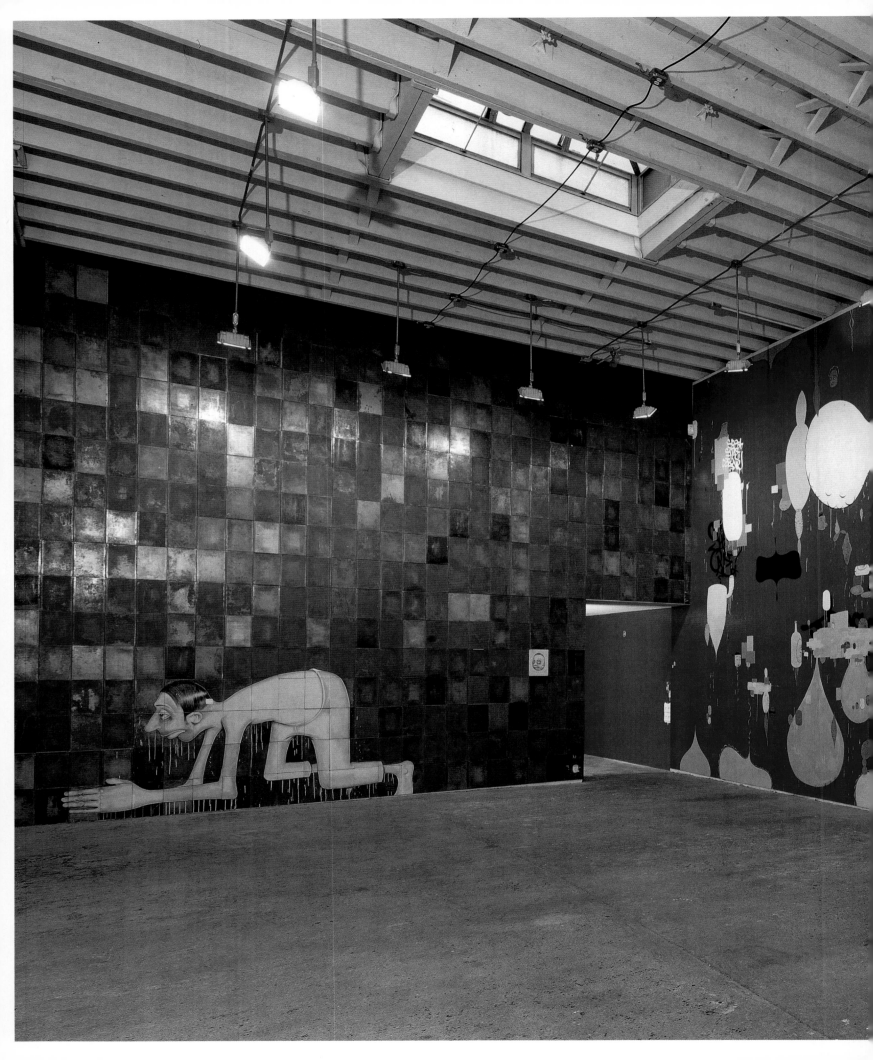

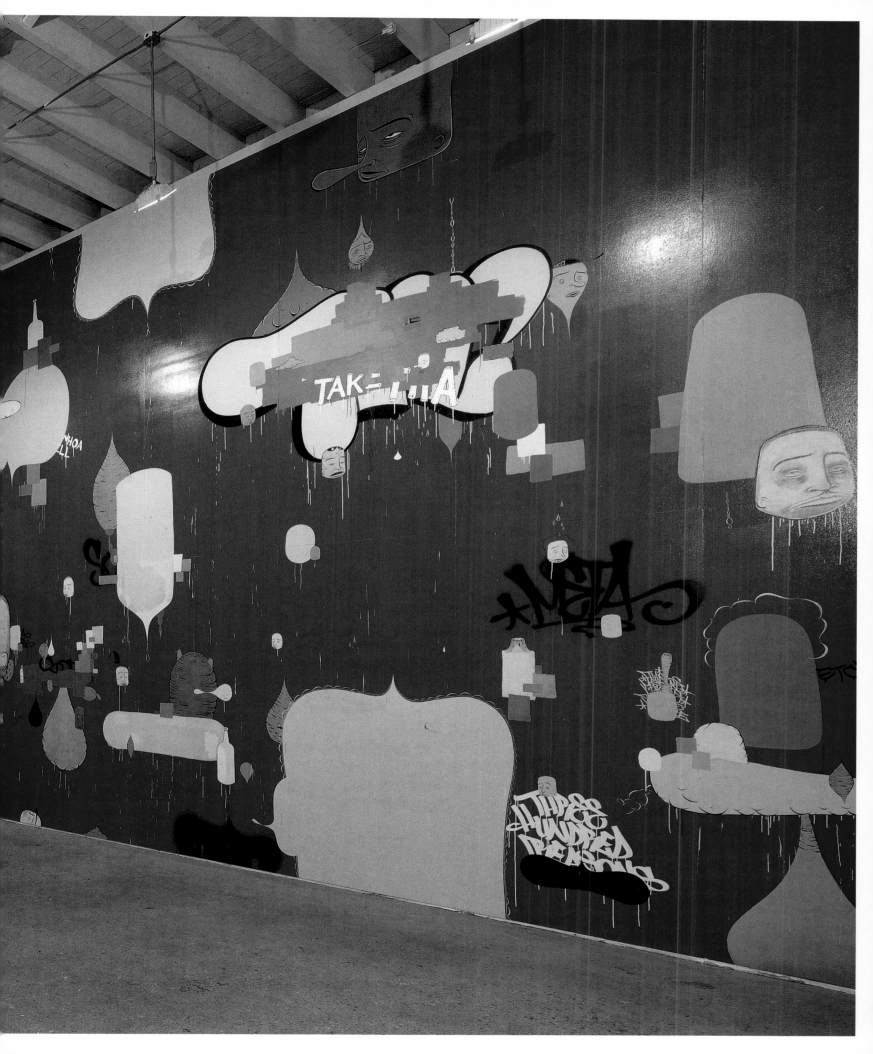

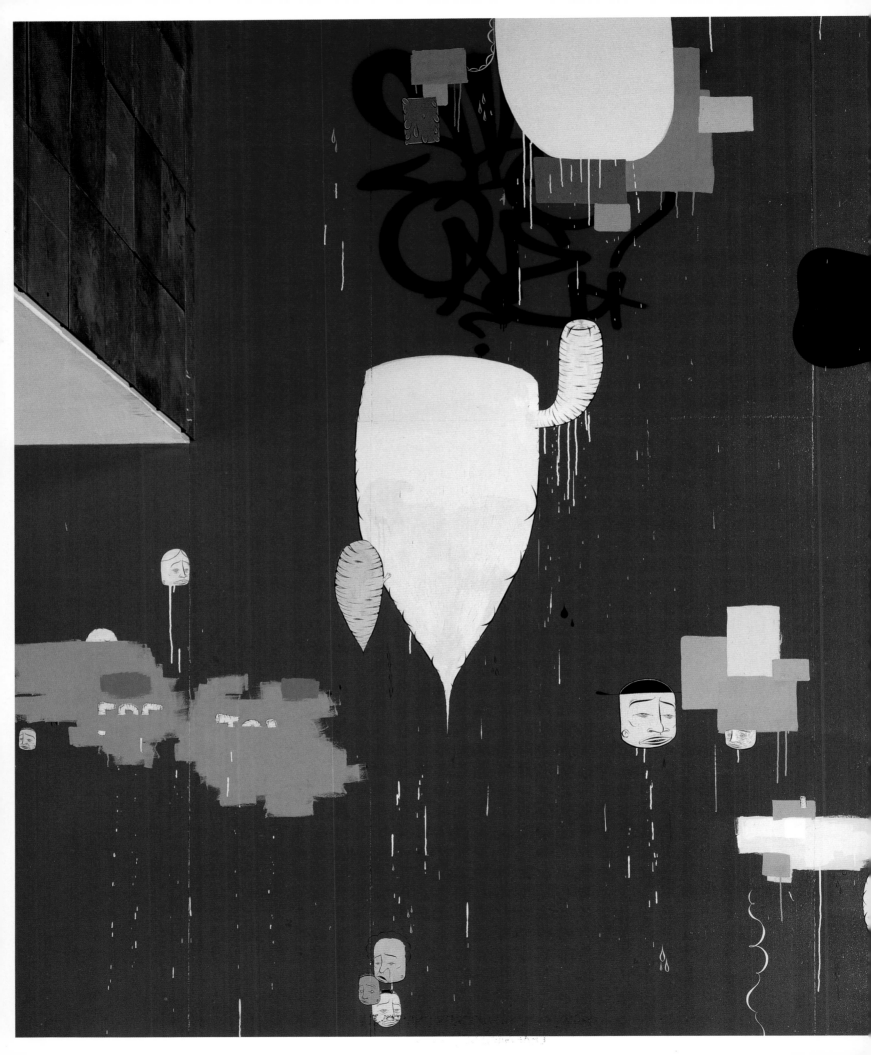

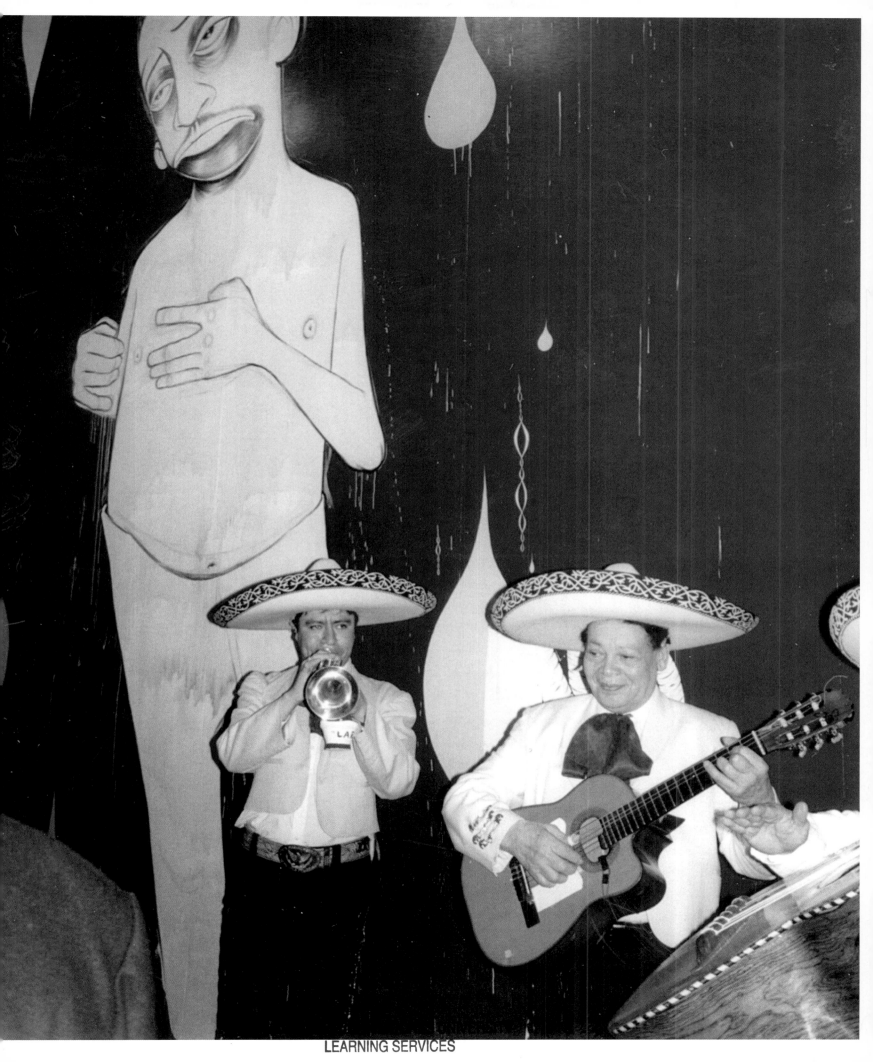

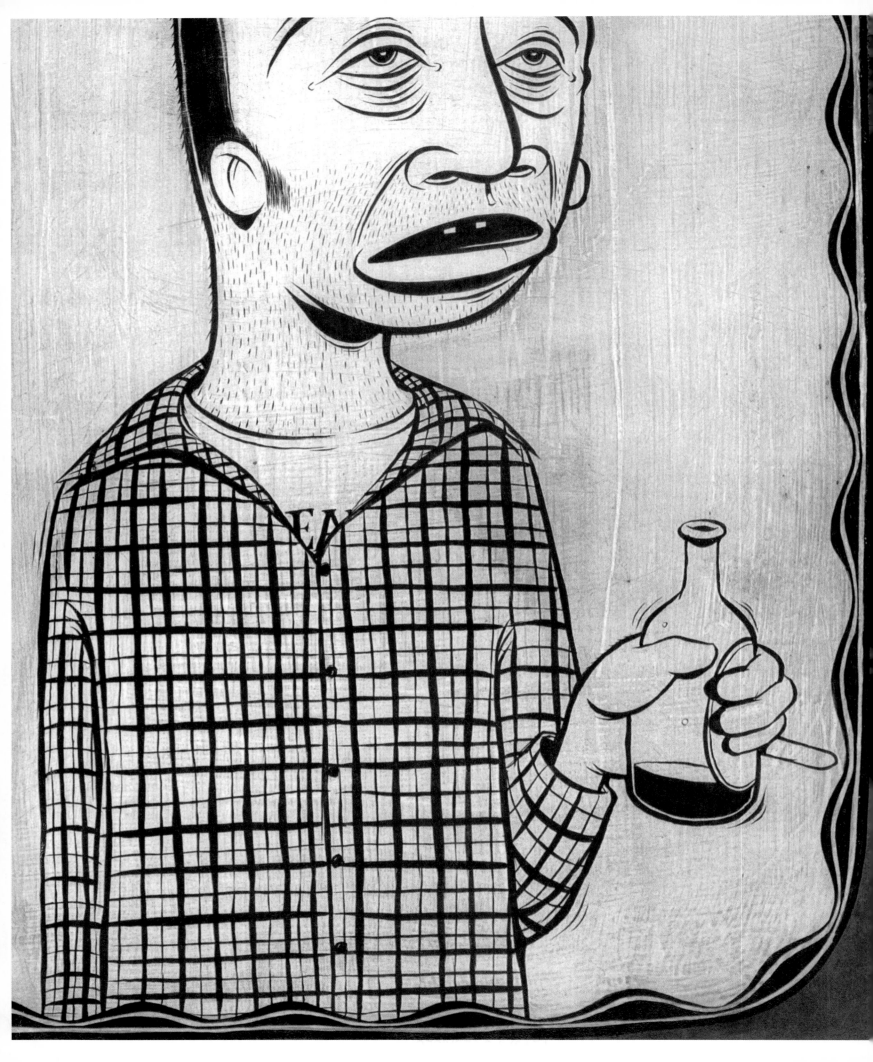

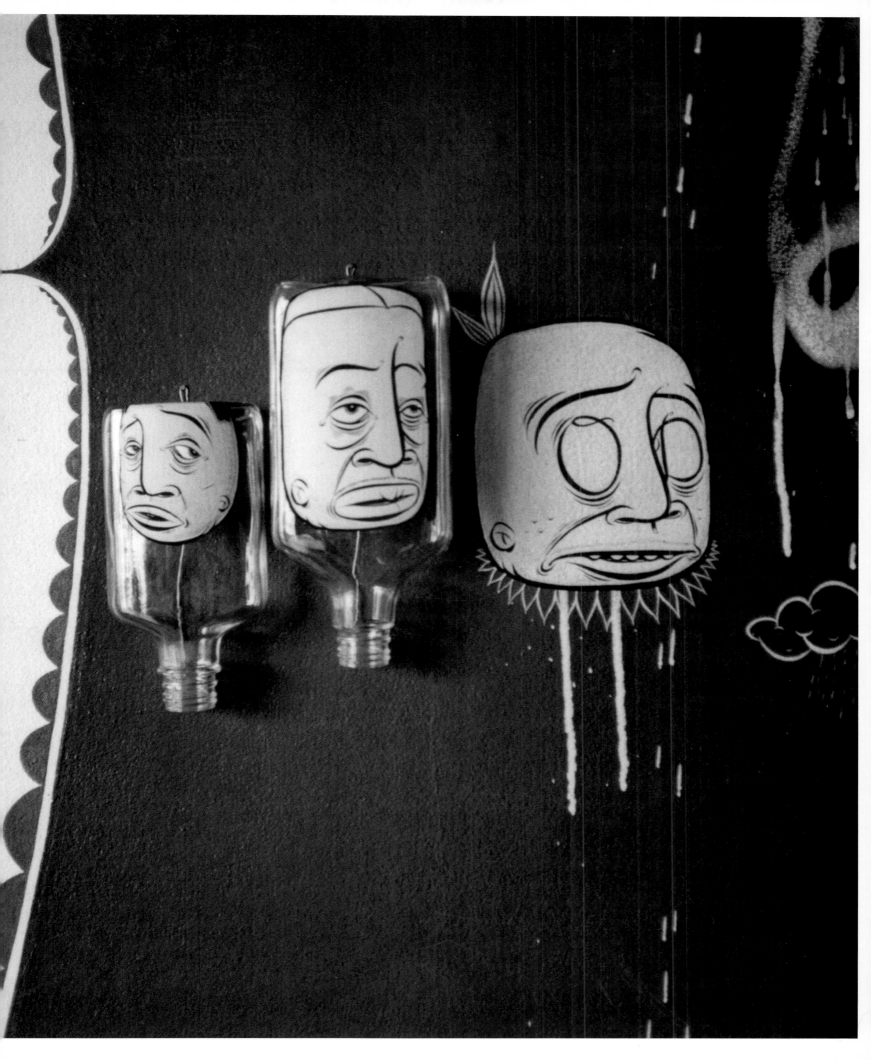

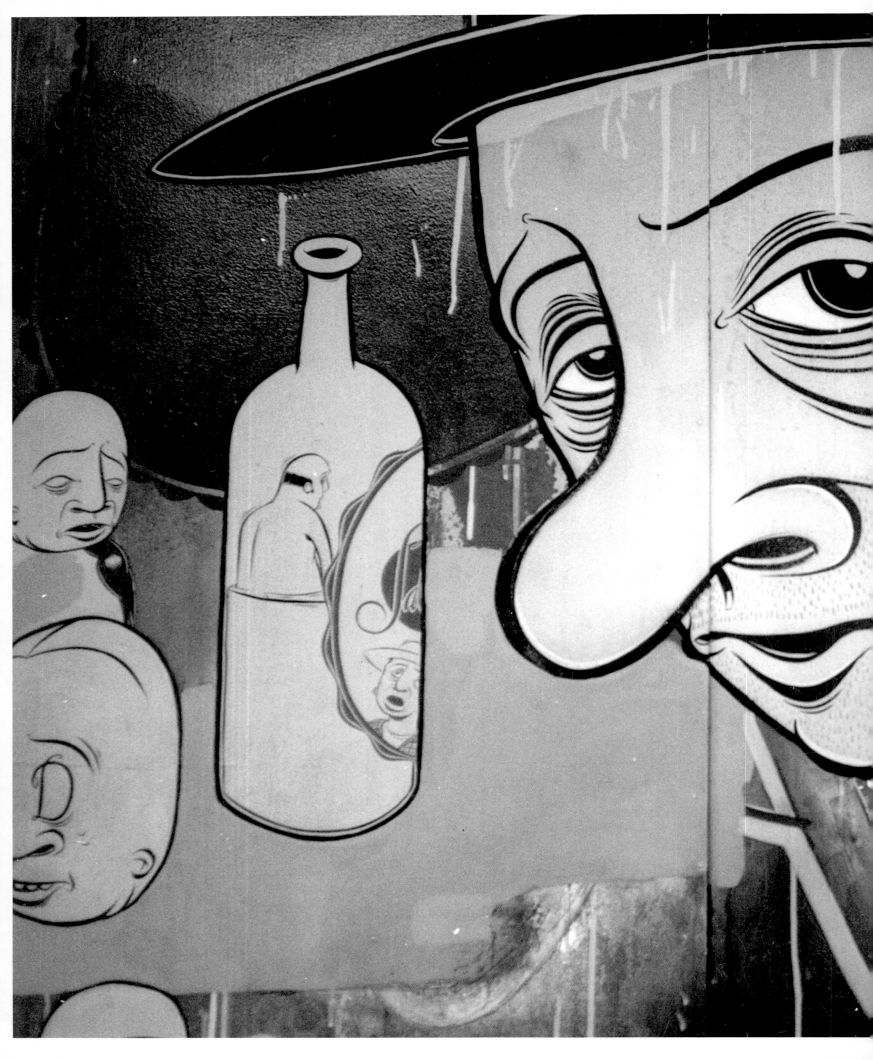

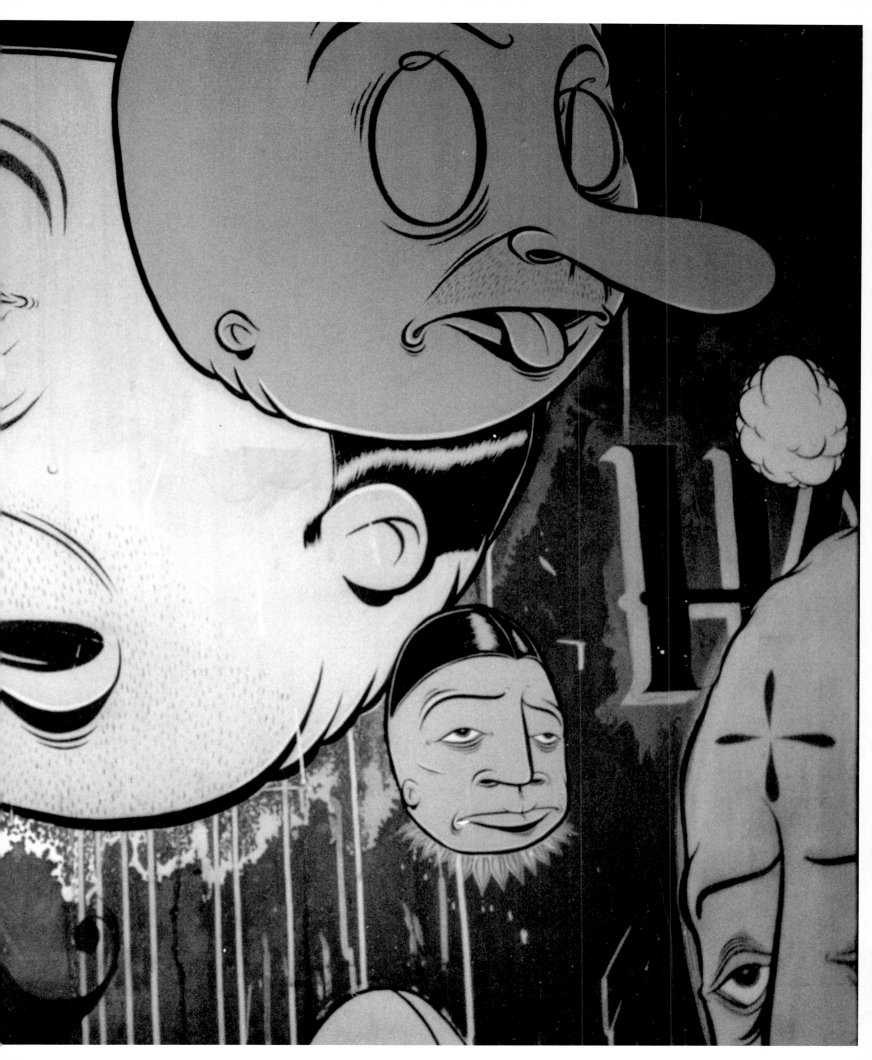

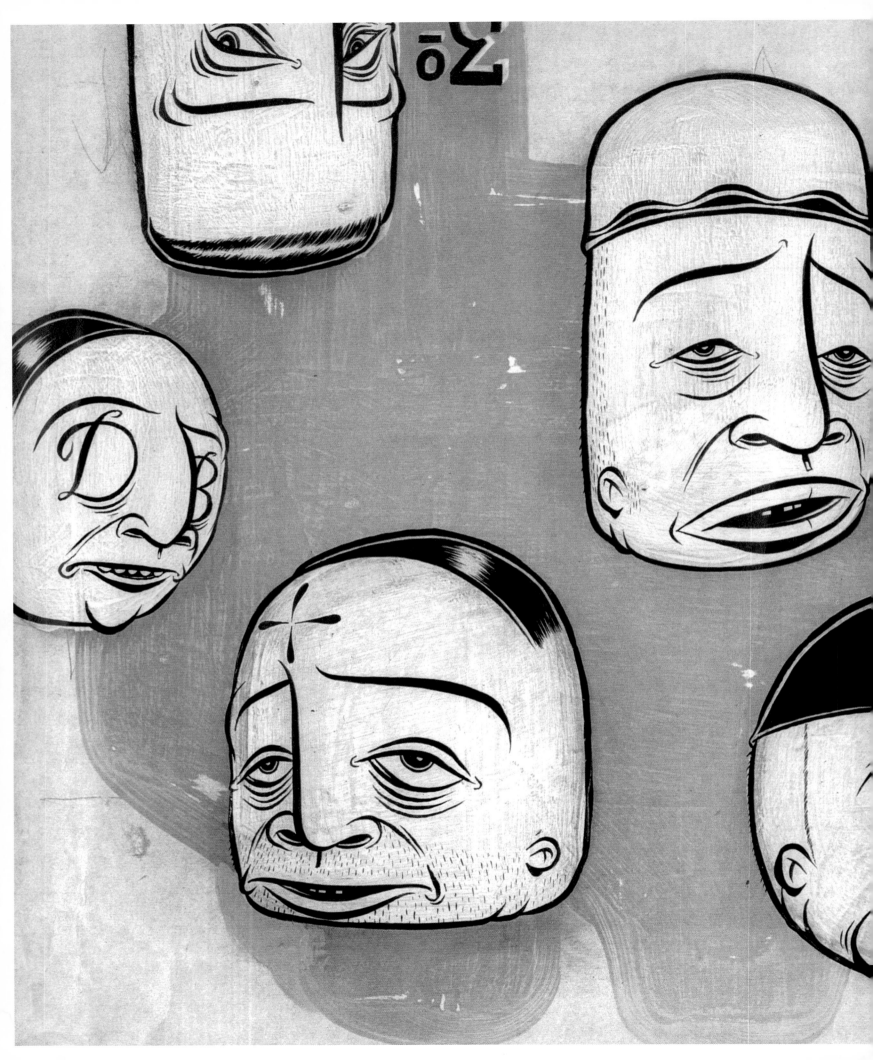

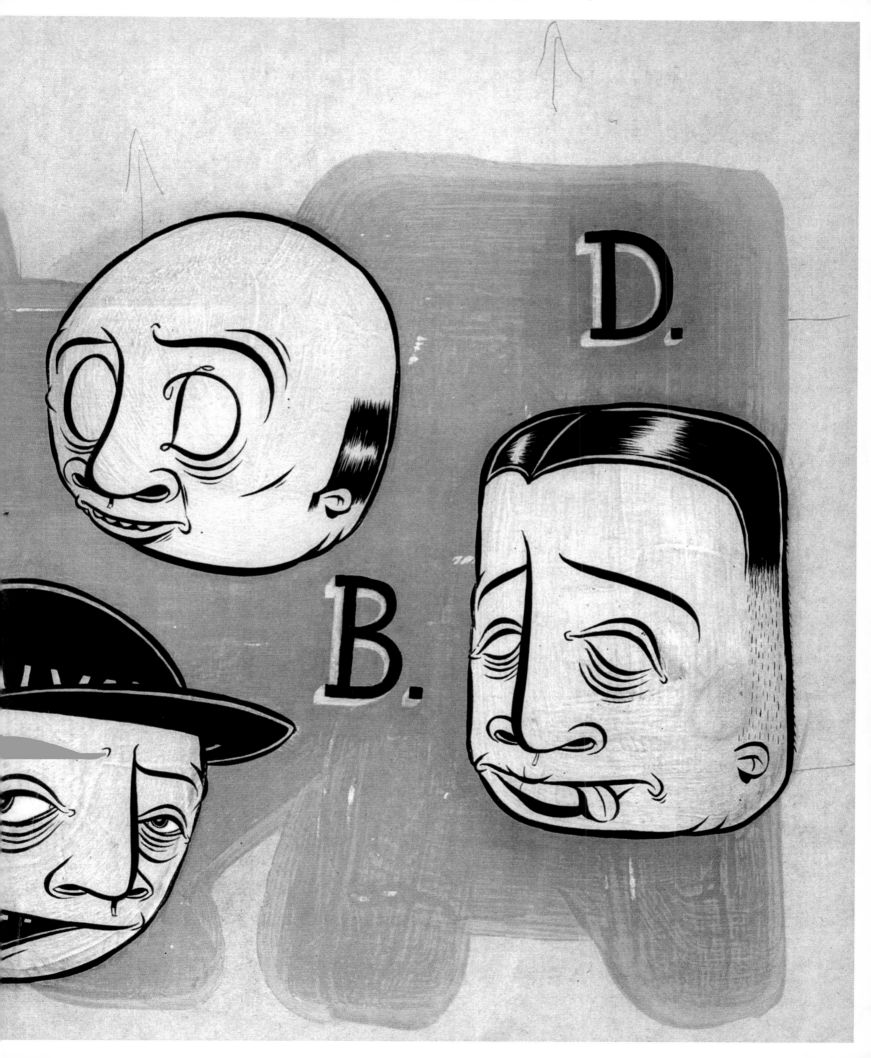

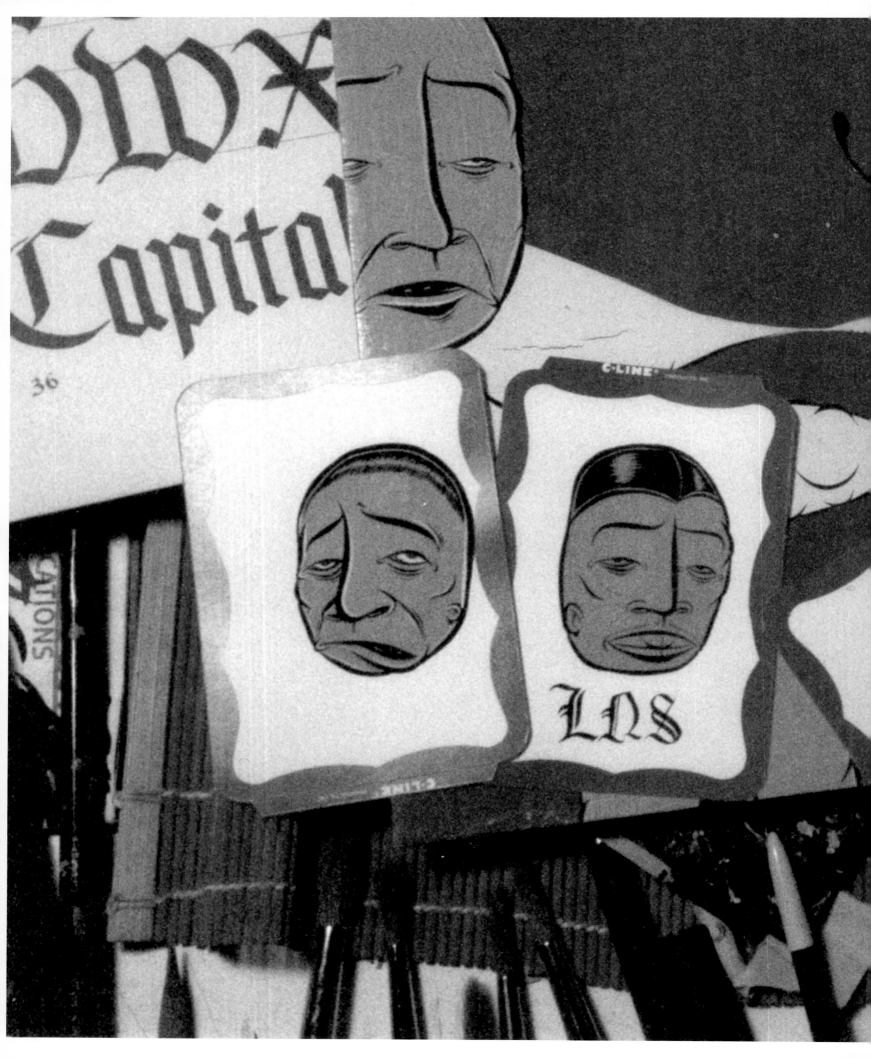

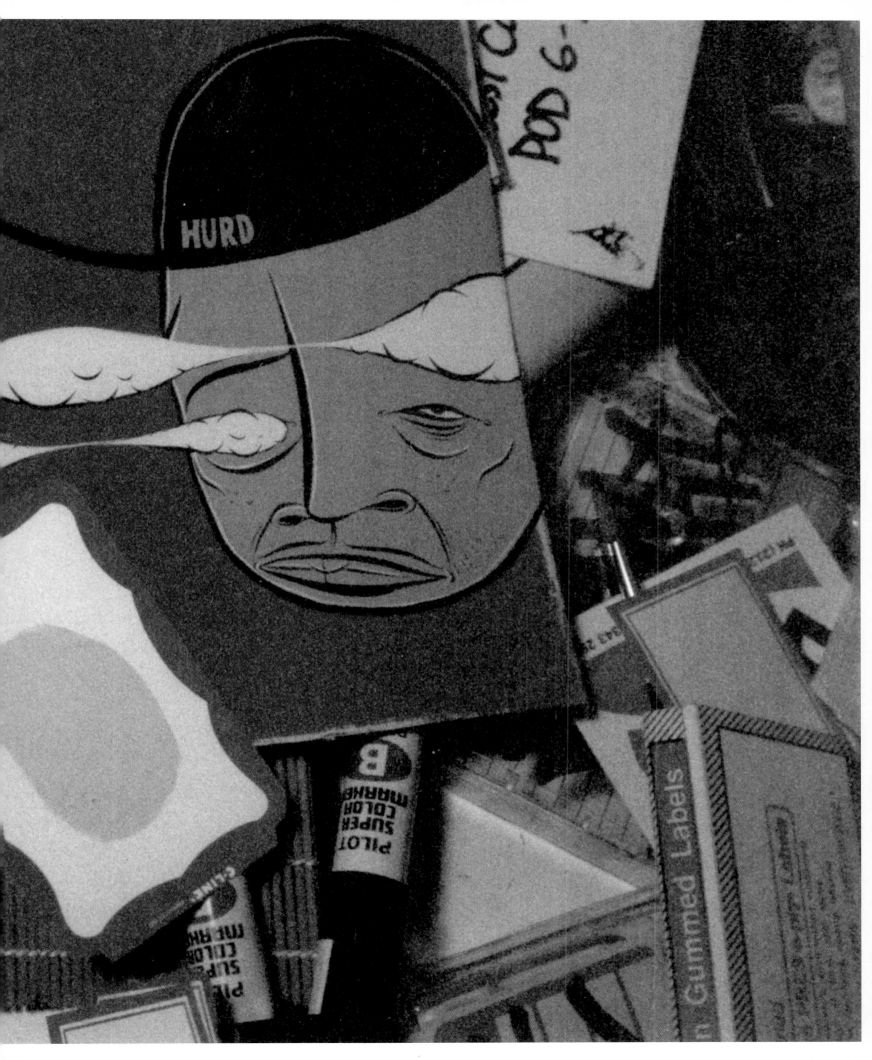

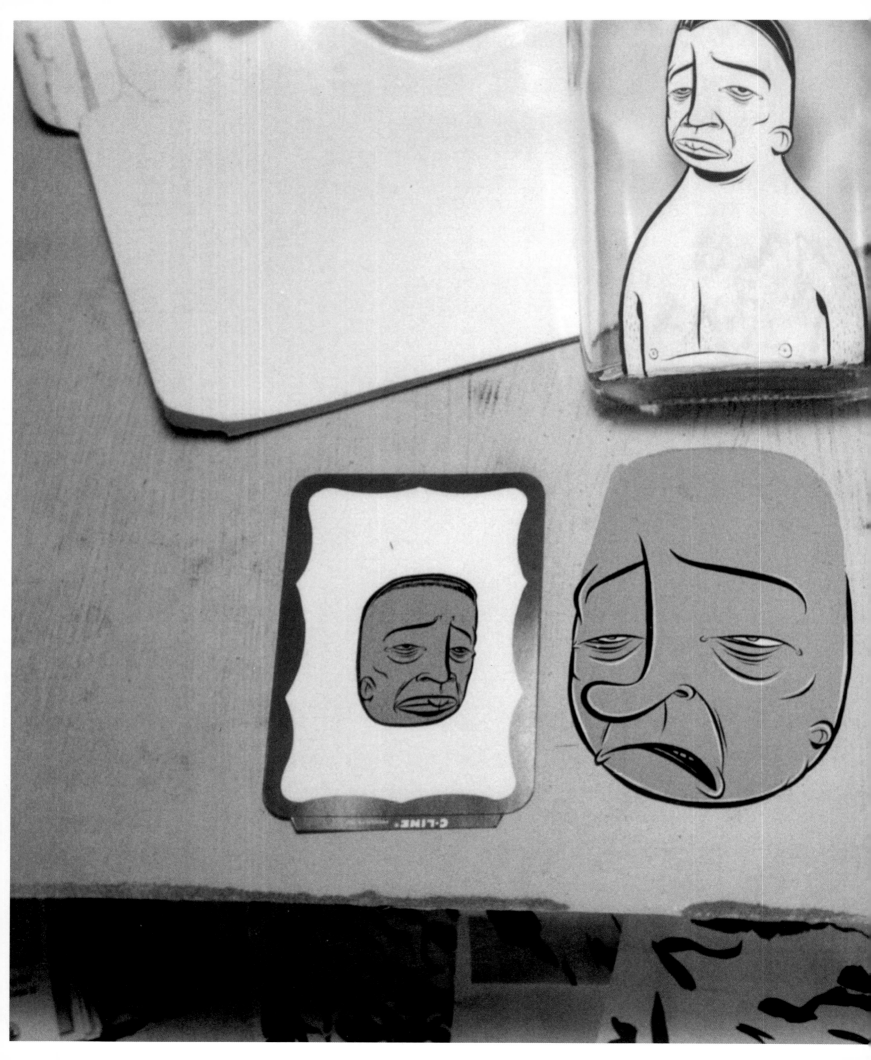

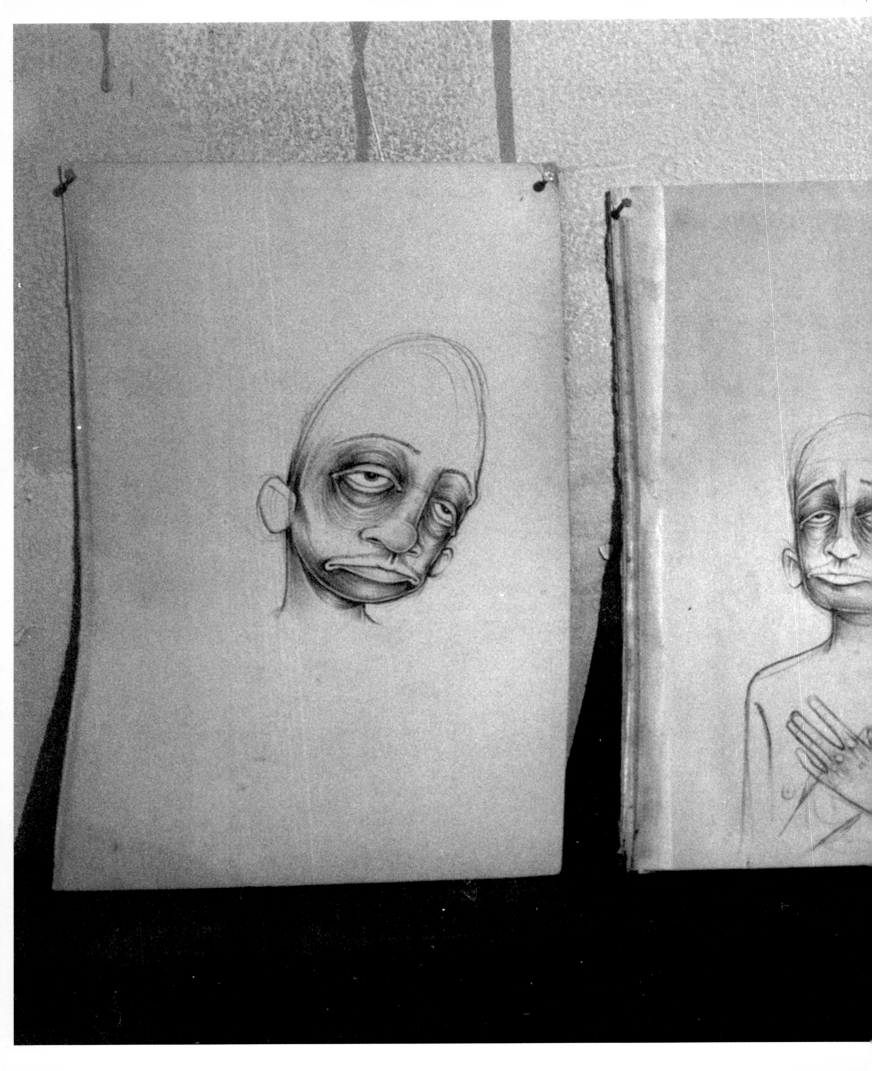

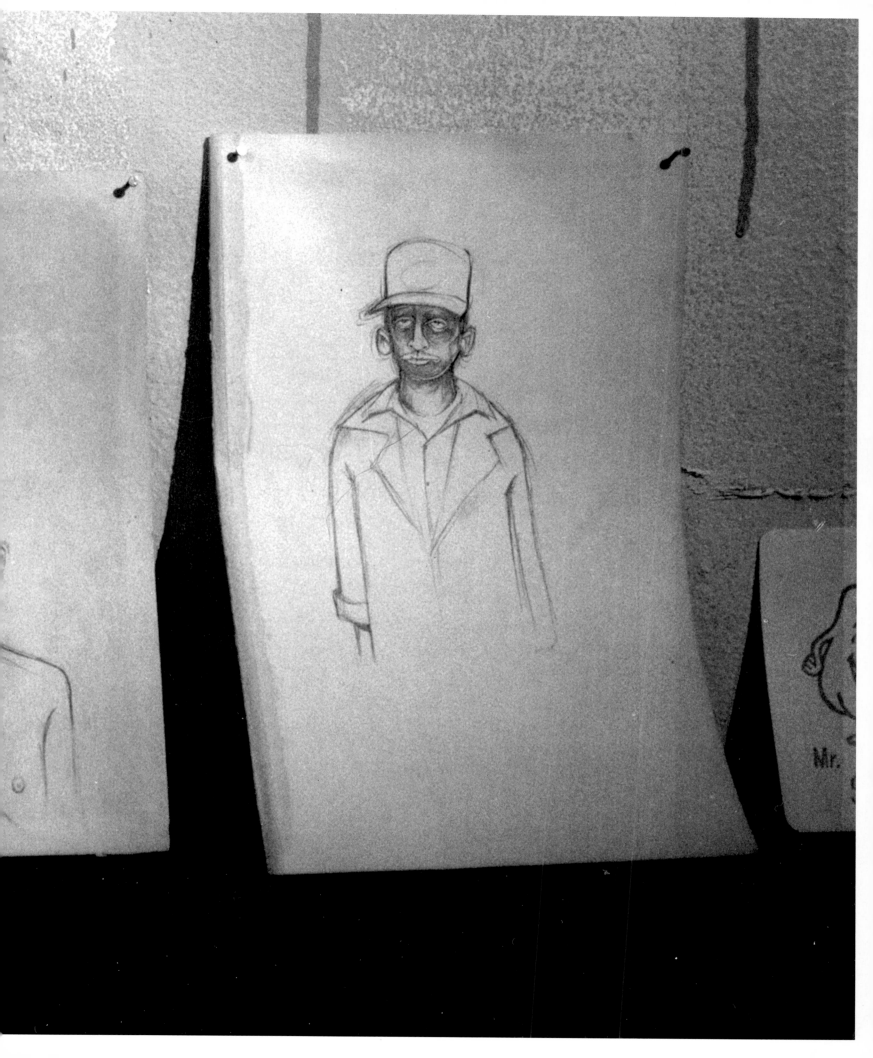

Mr.

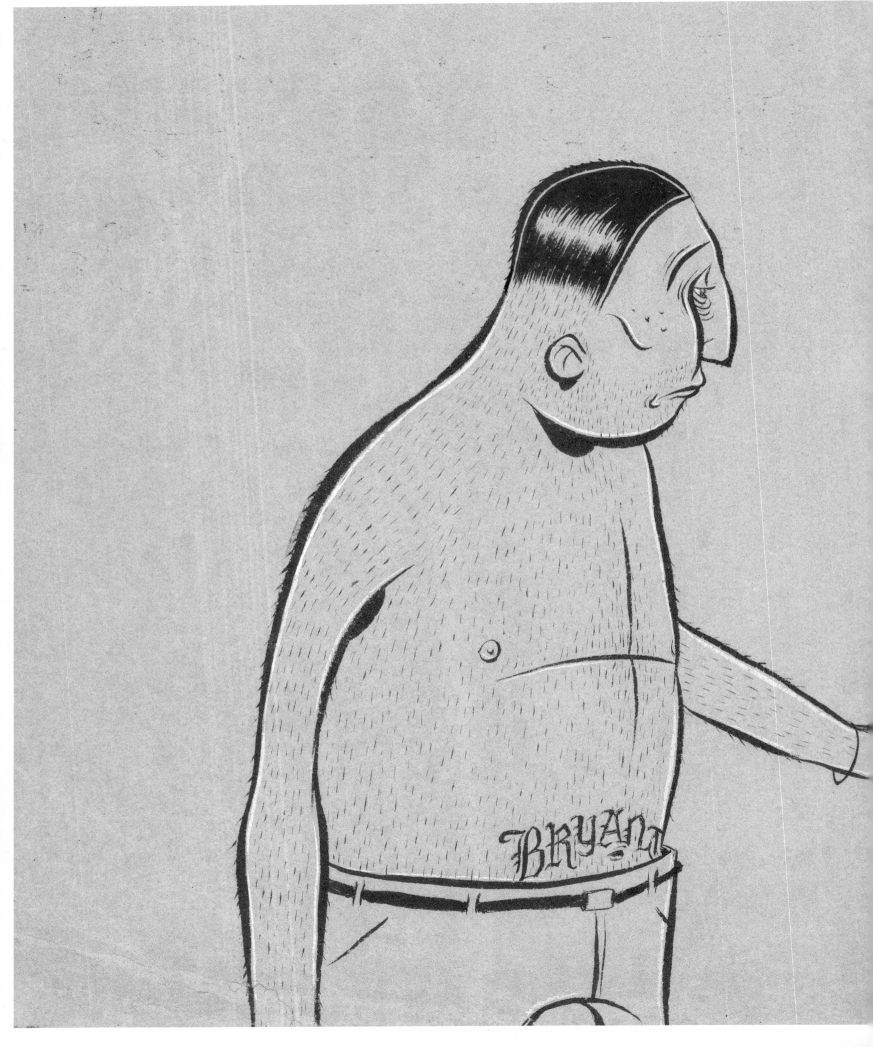

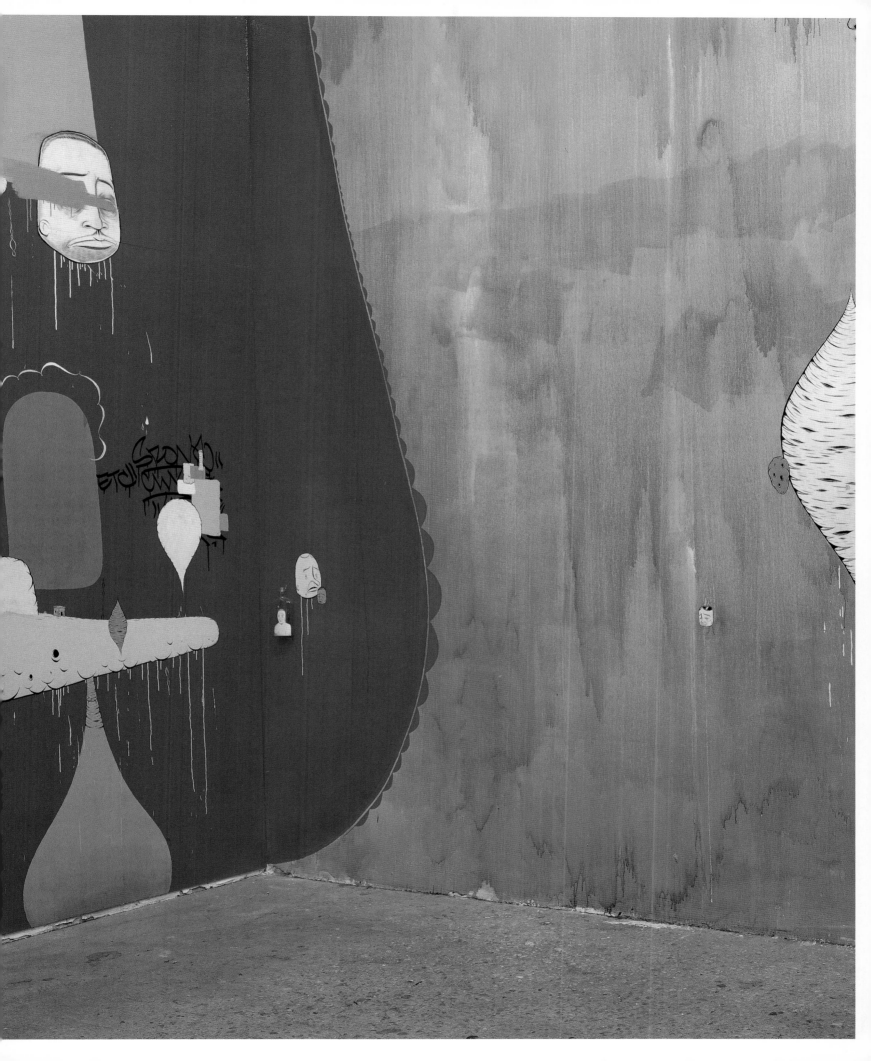

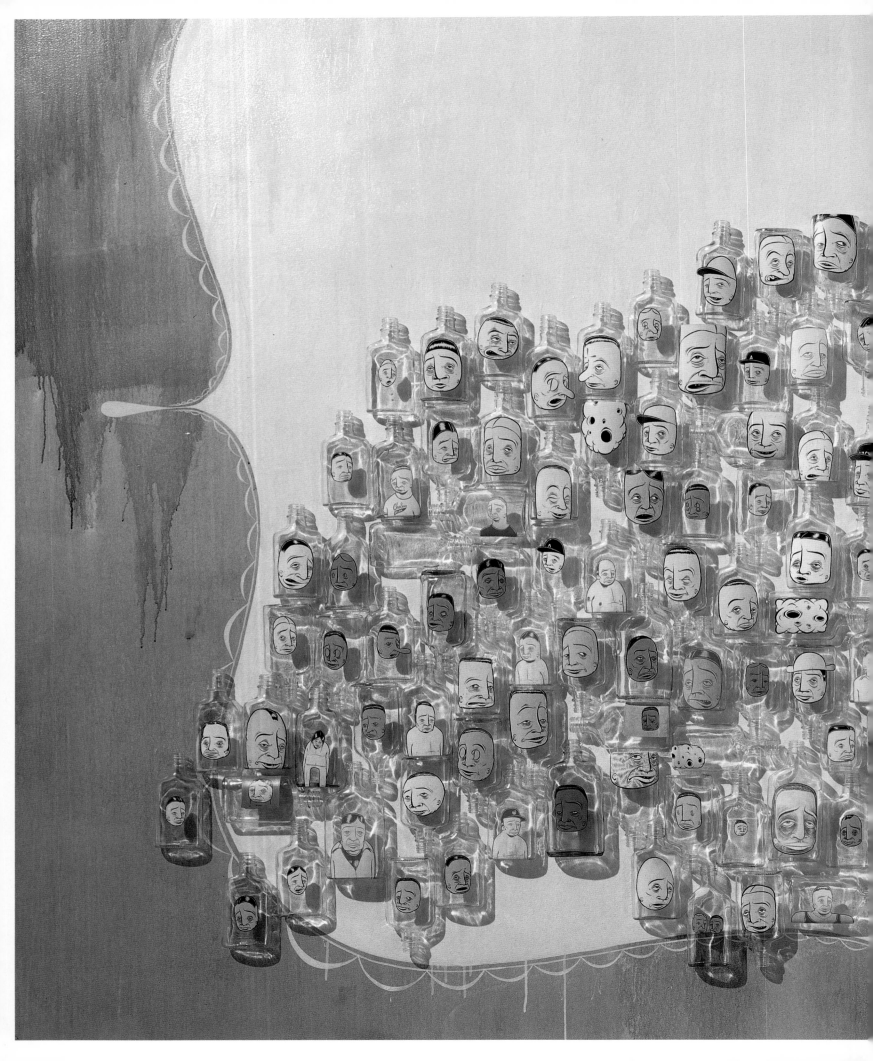

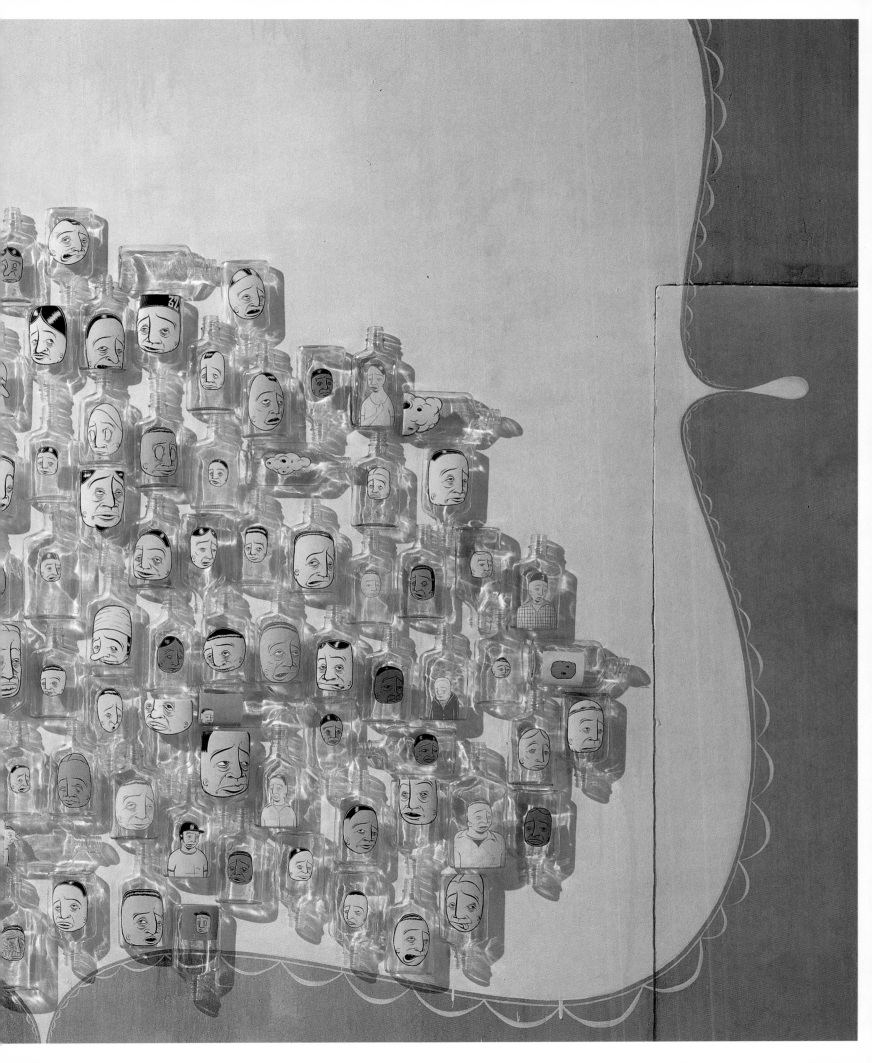

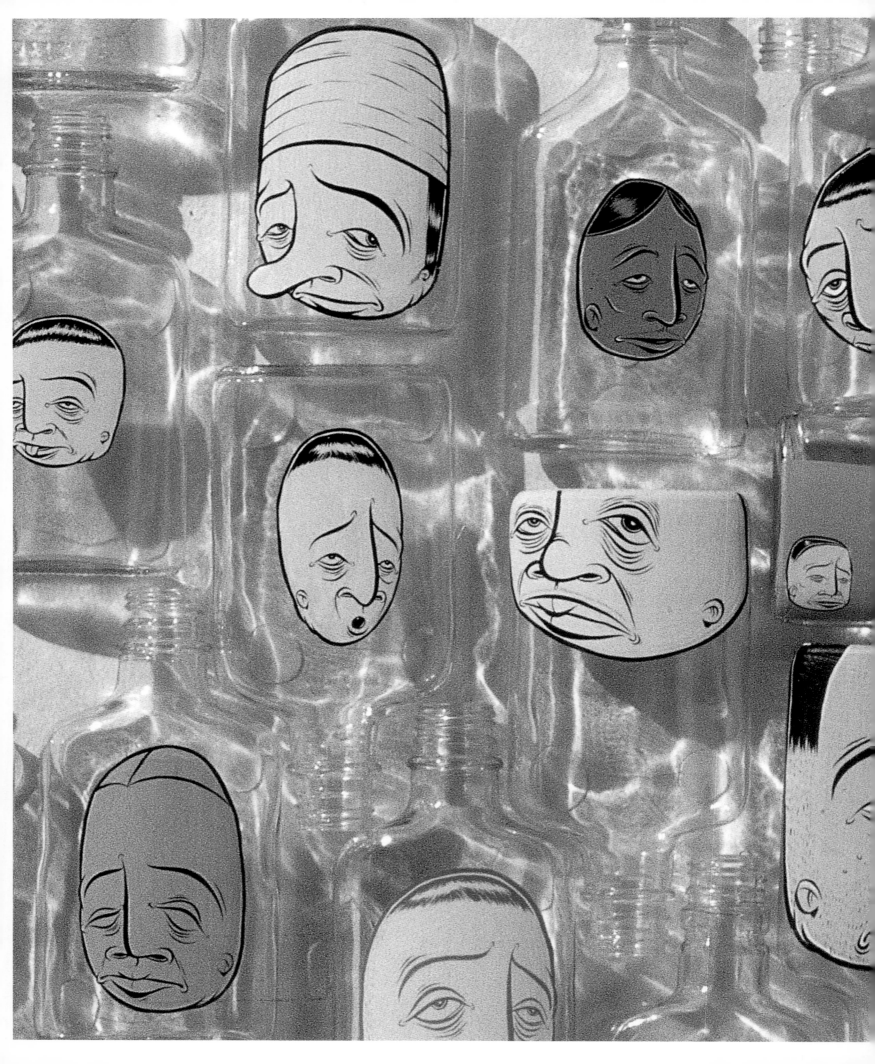

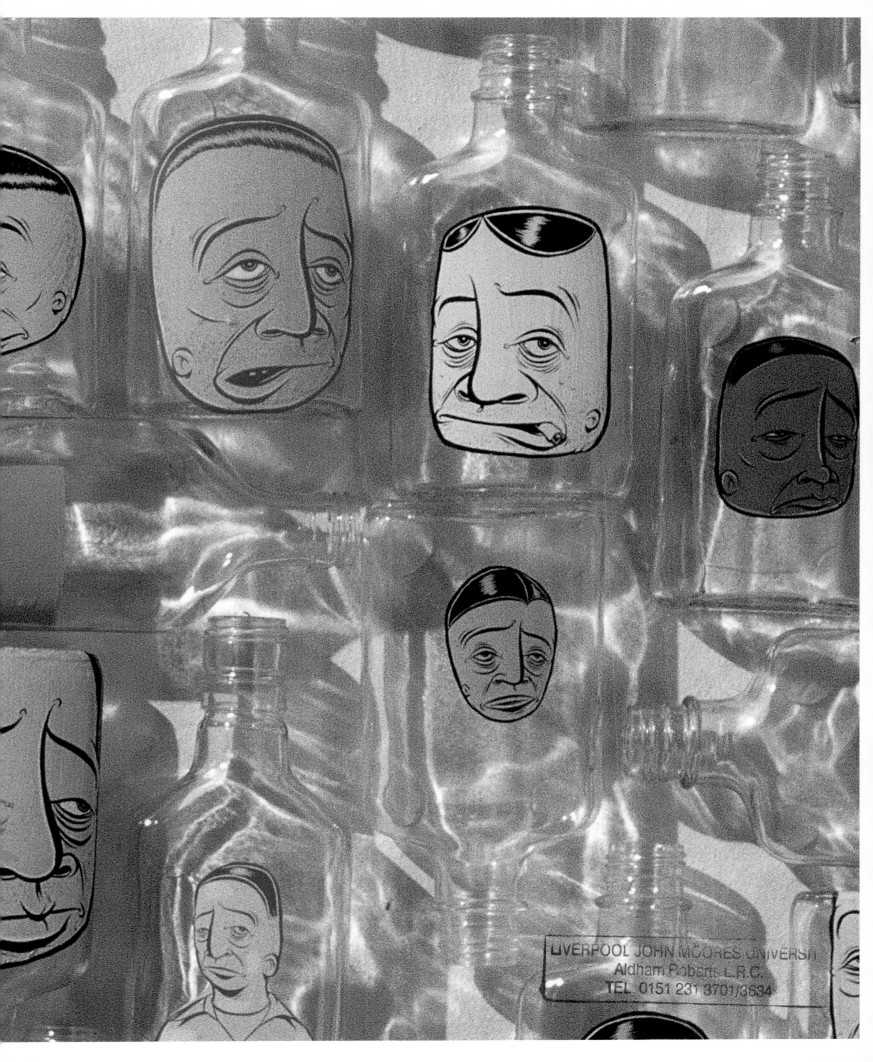

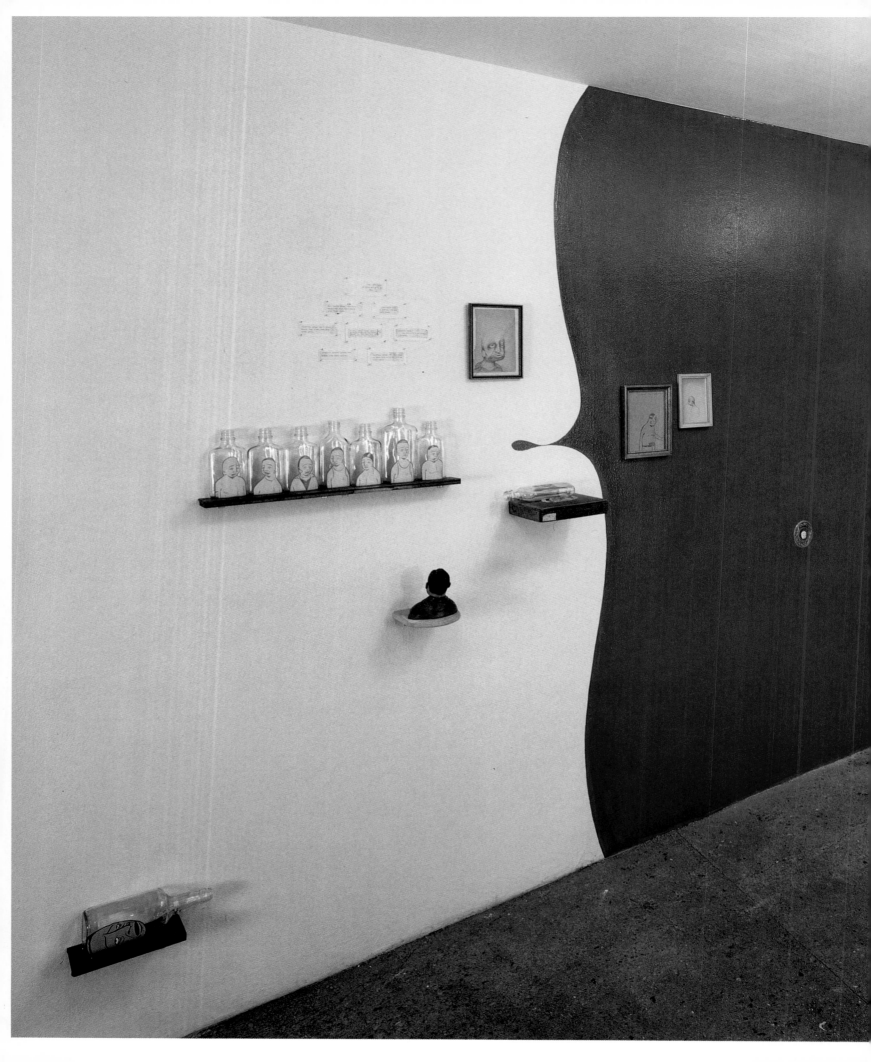

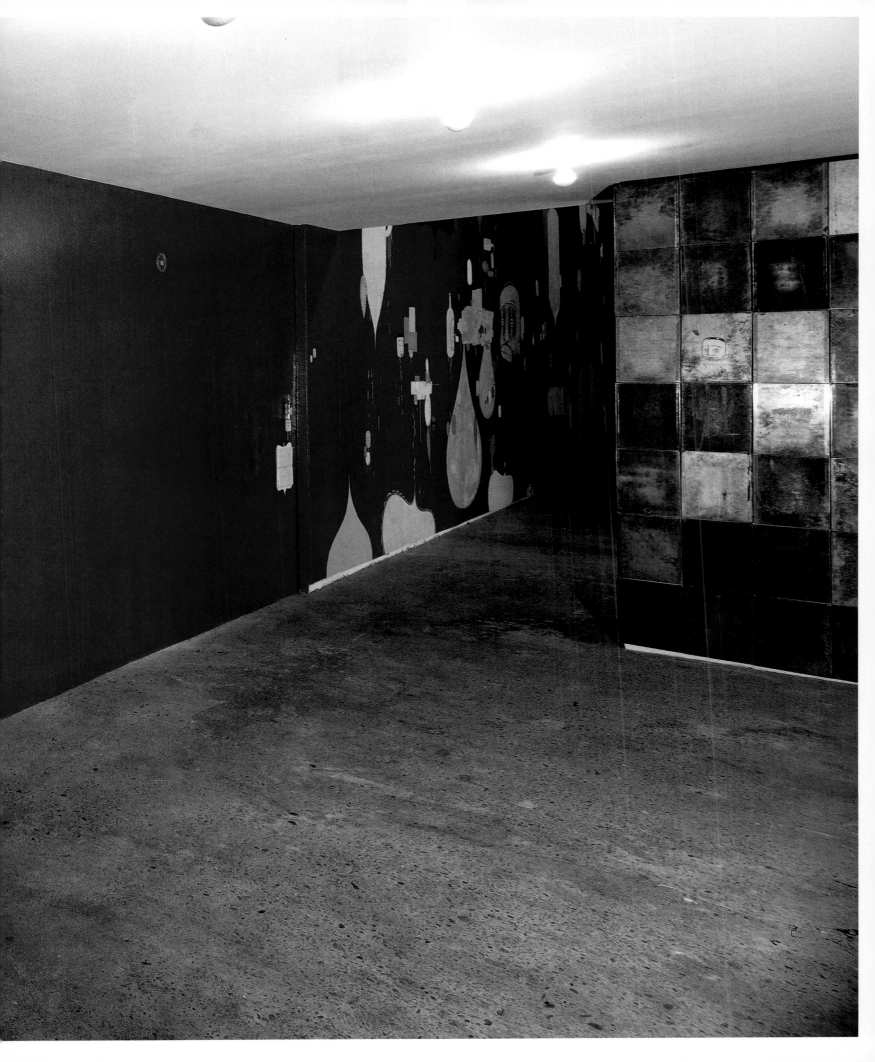

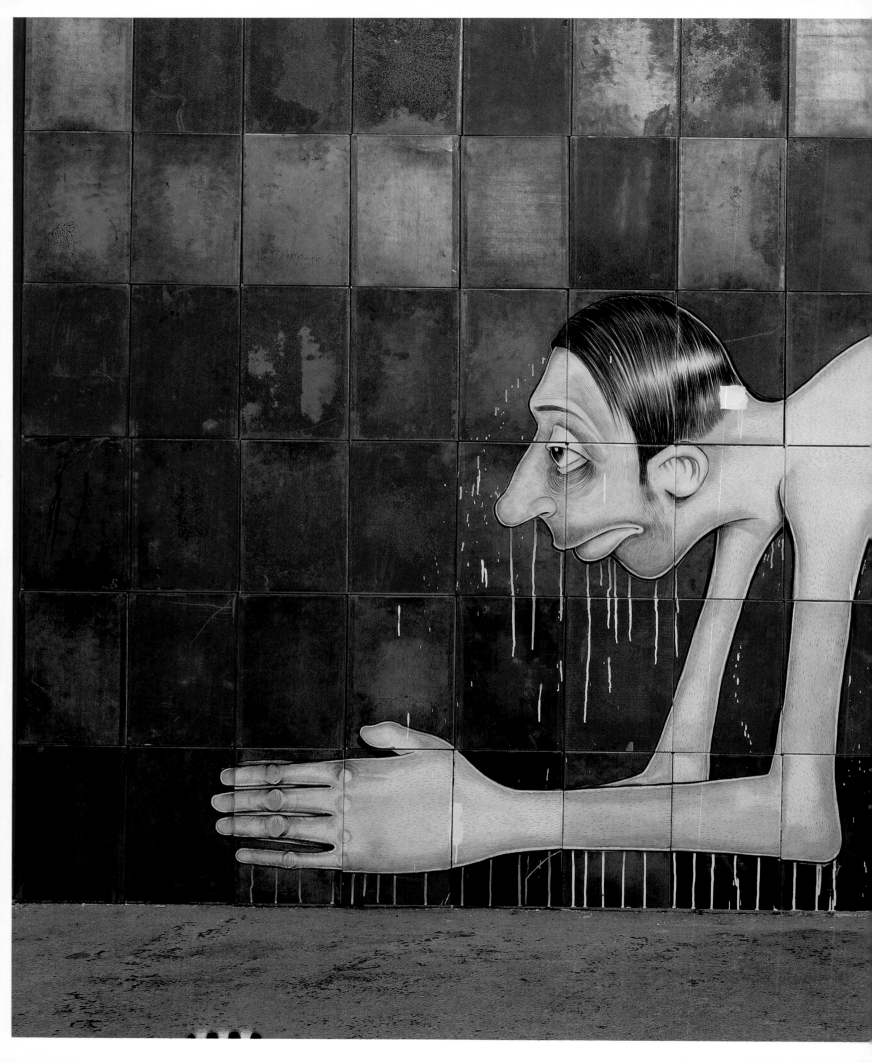

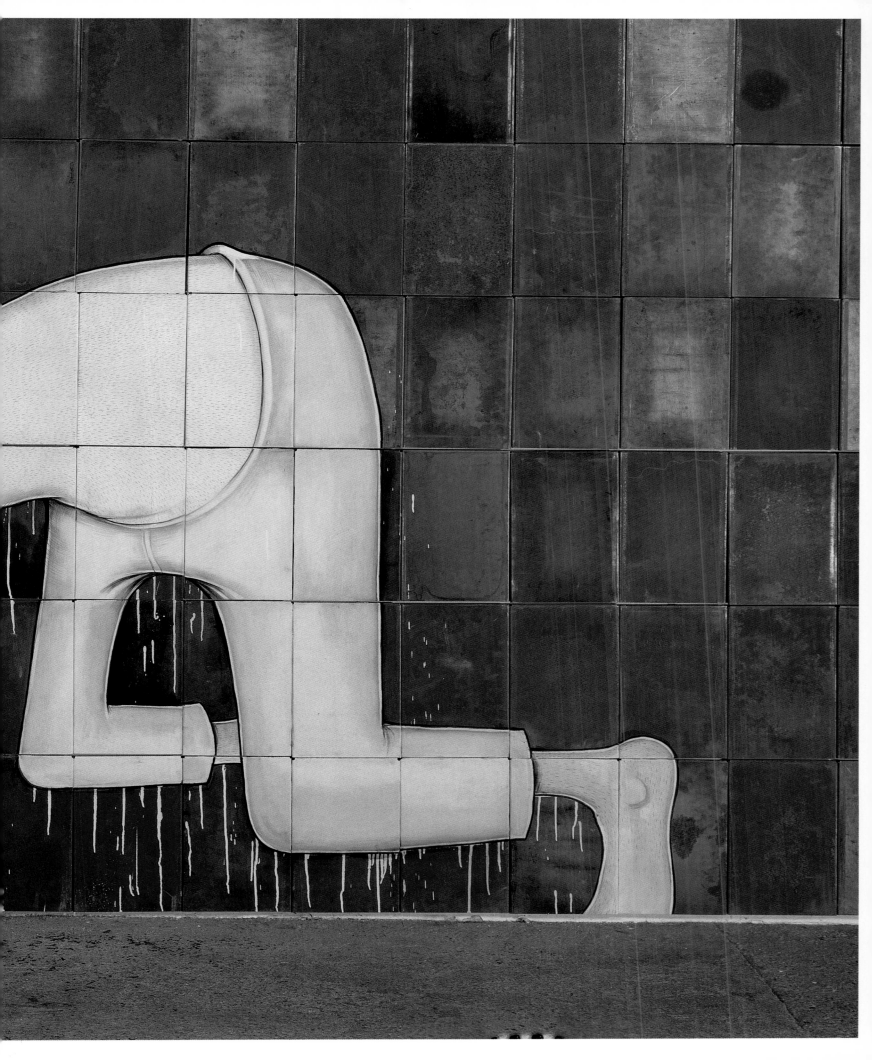

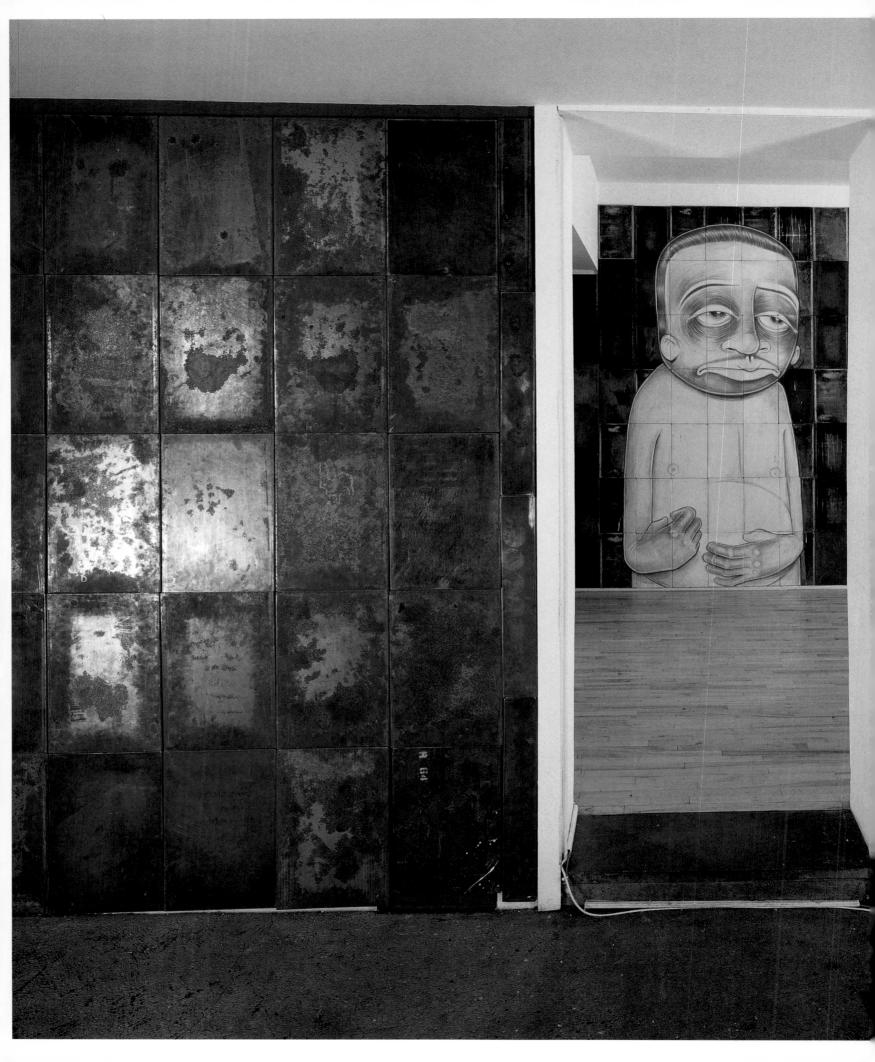

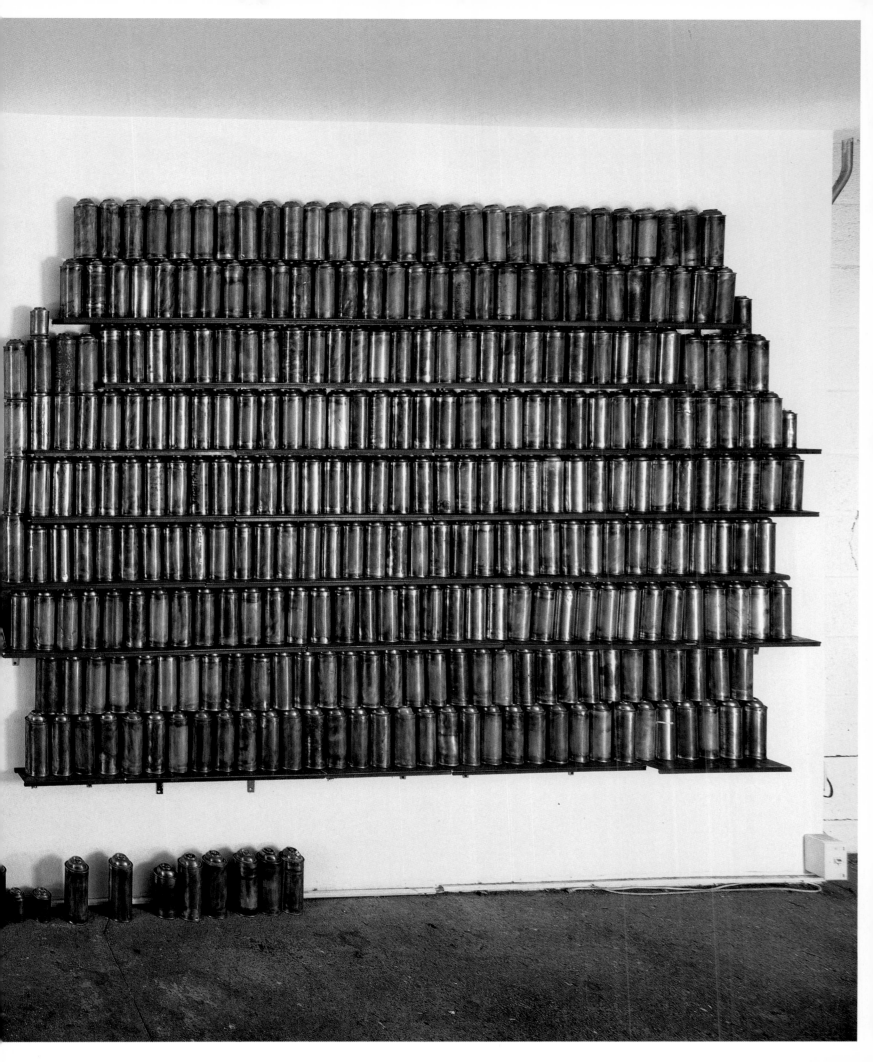

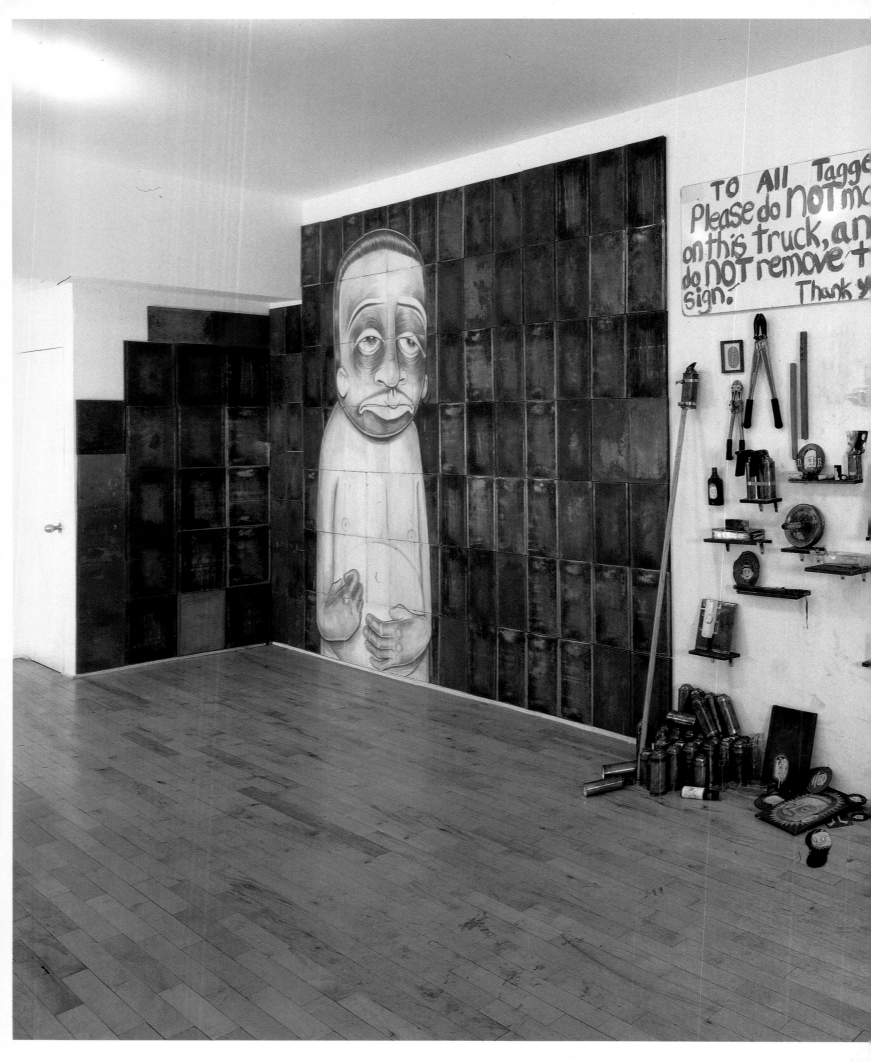

TO All Tagge
Please do NOT ma
on this truck, an
do NOT remove t
sign. Thank y

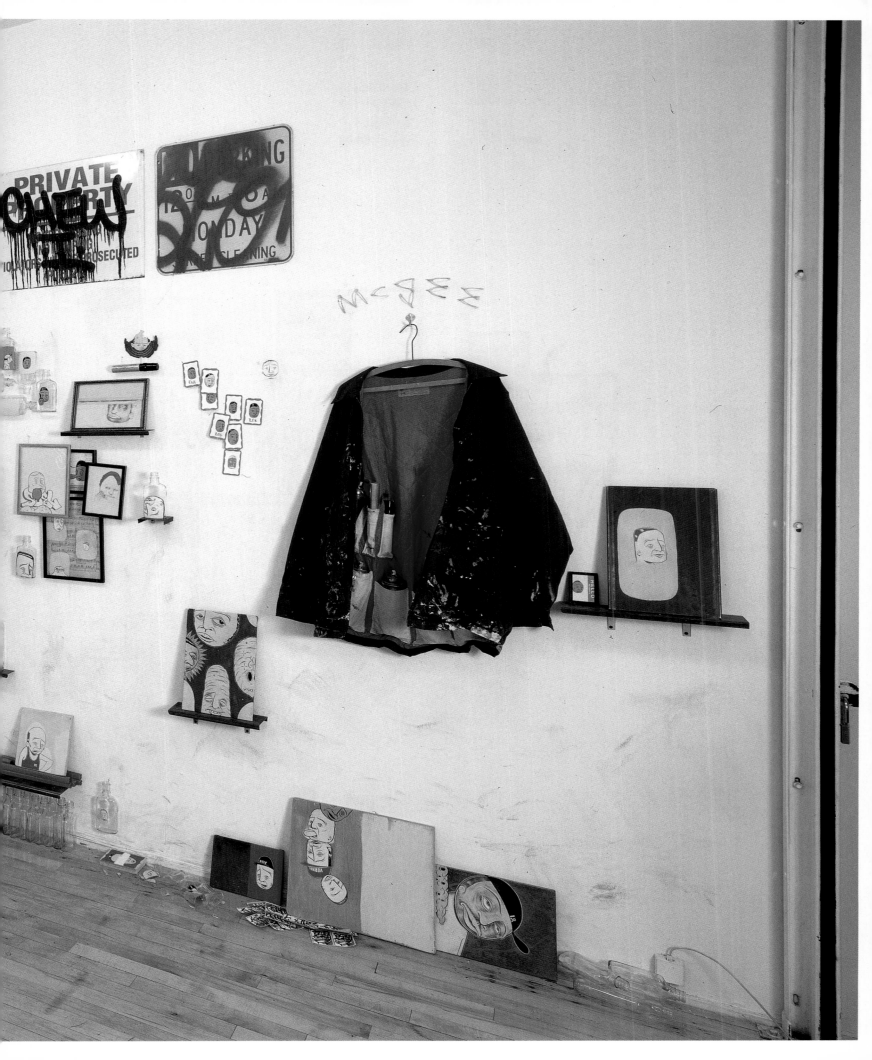

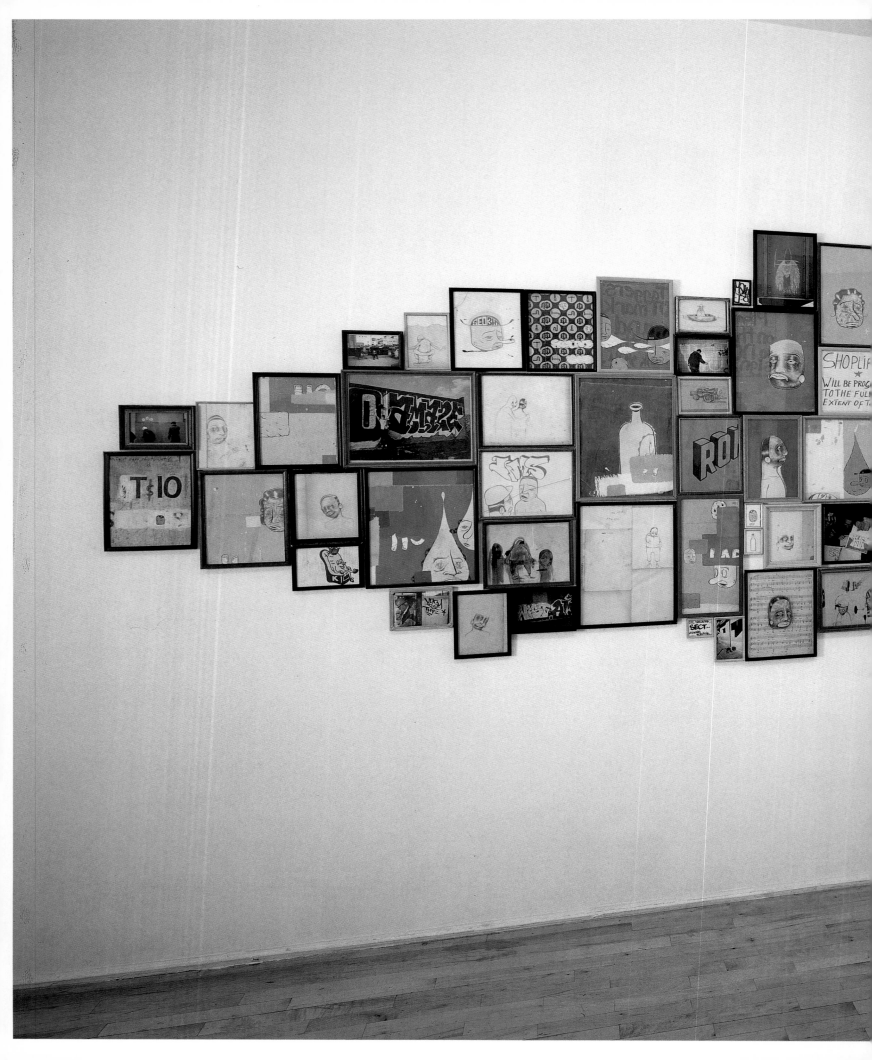

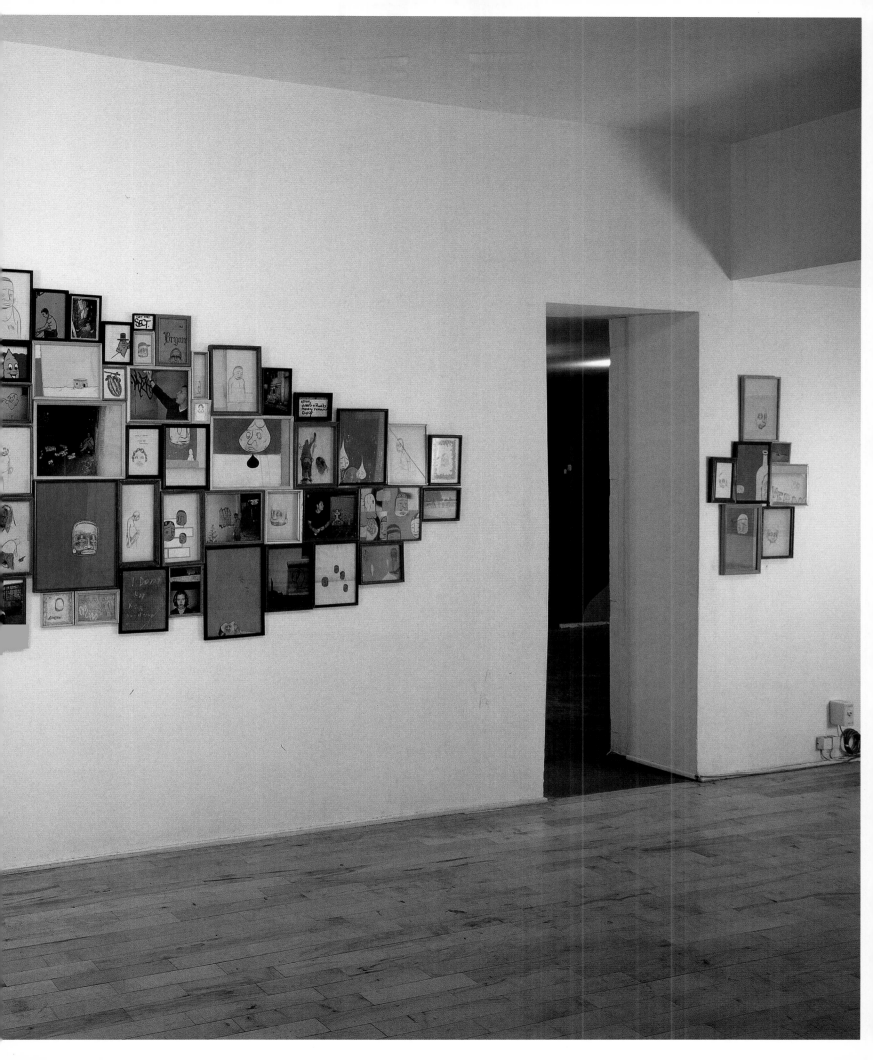

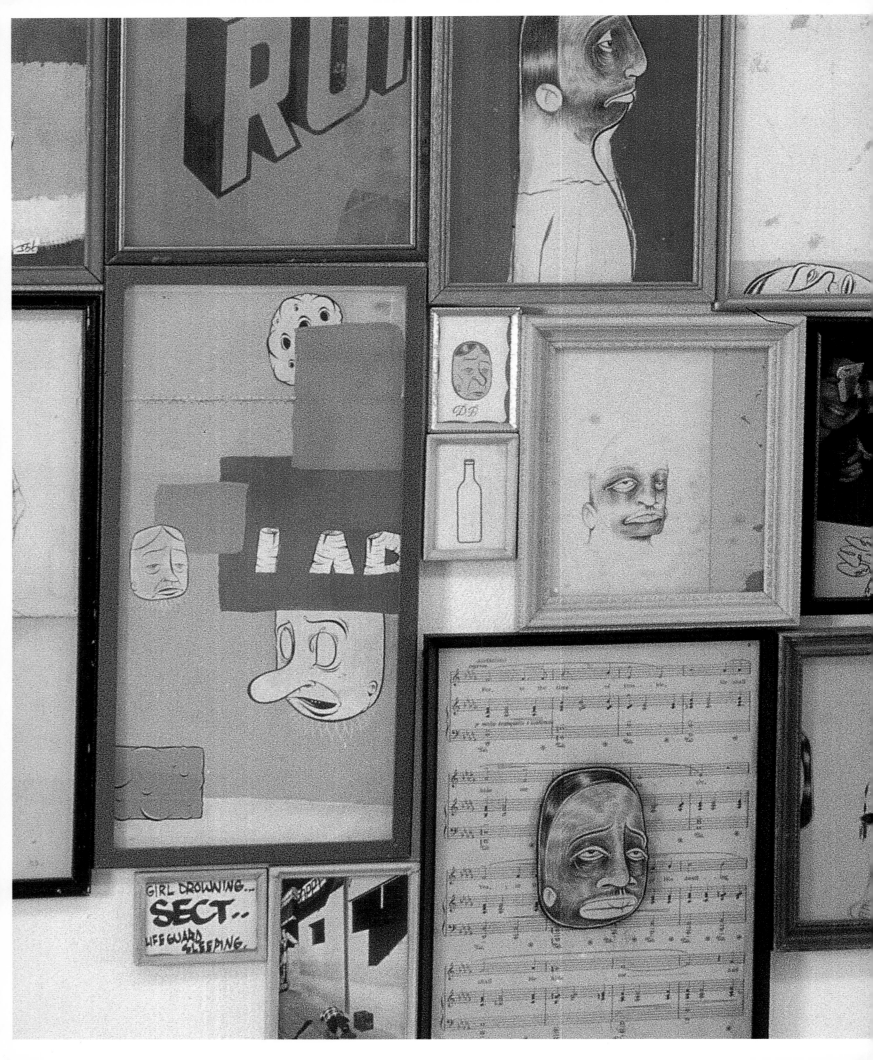

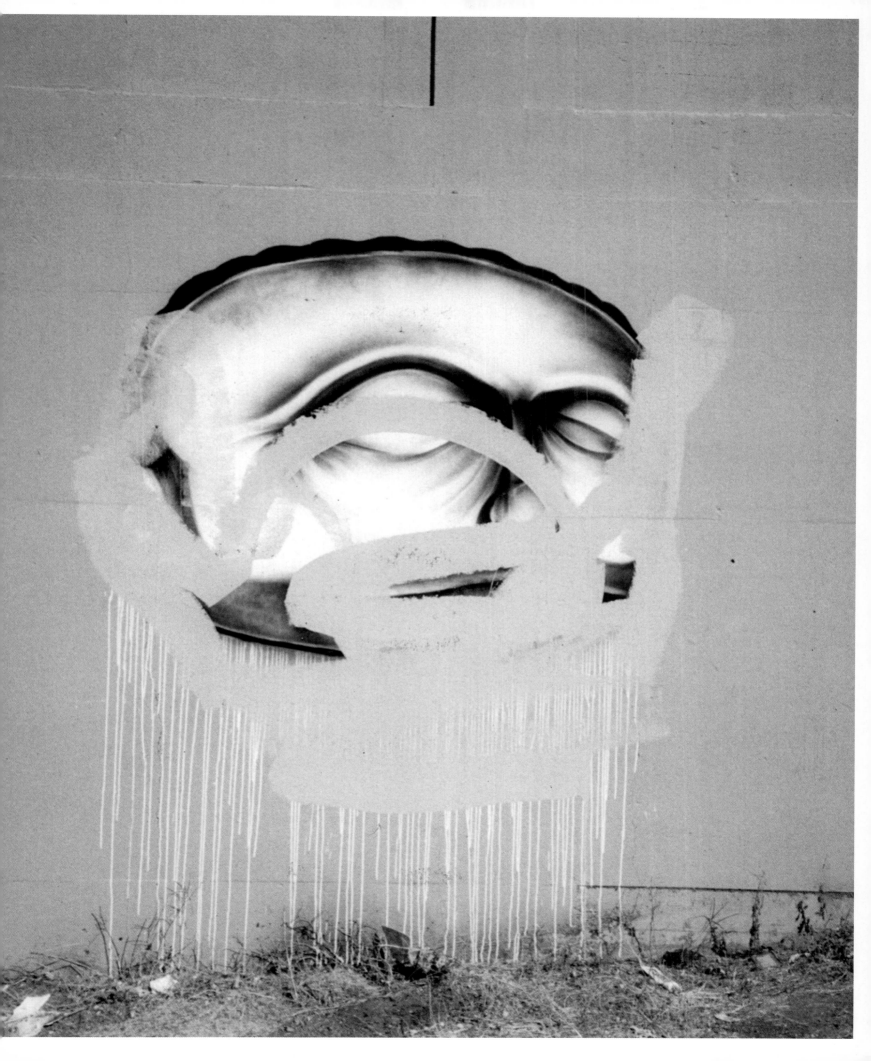

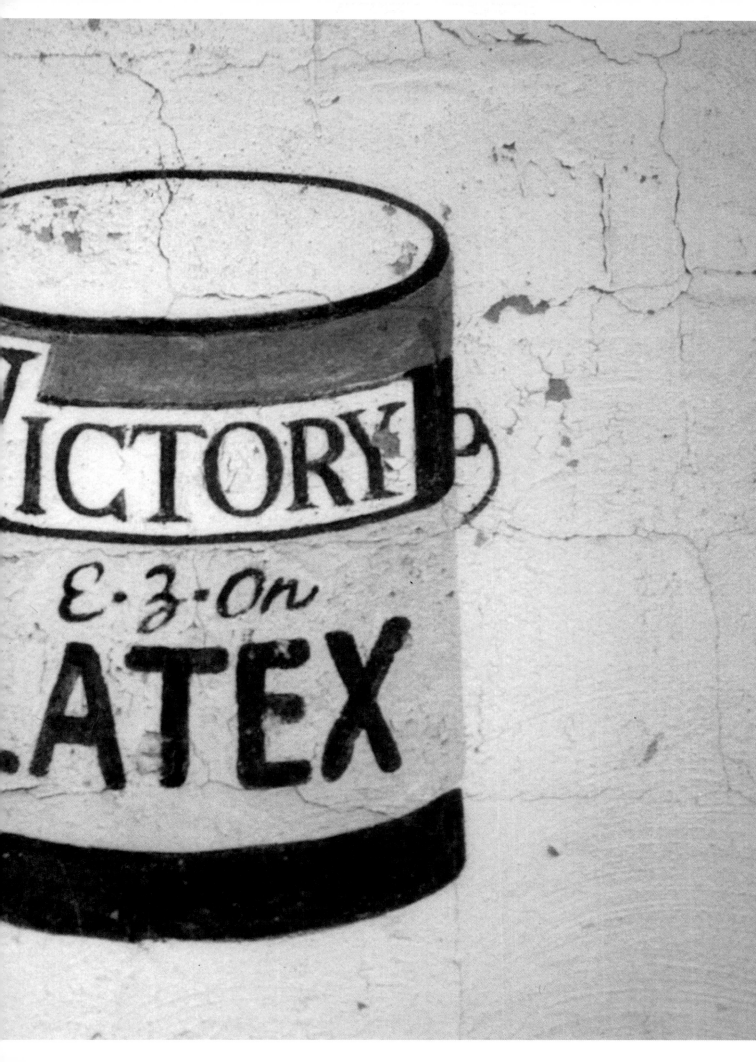

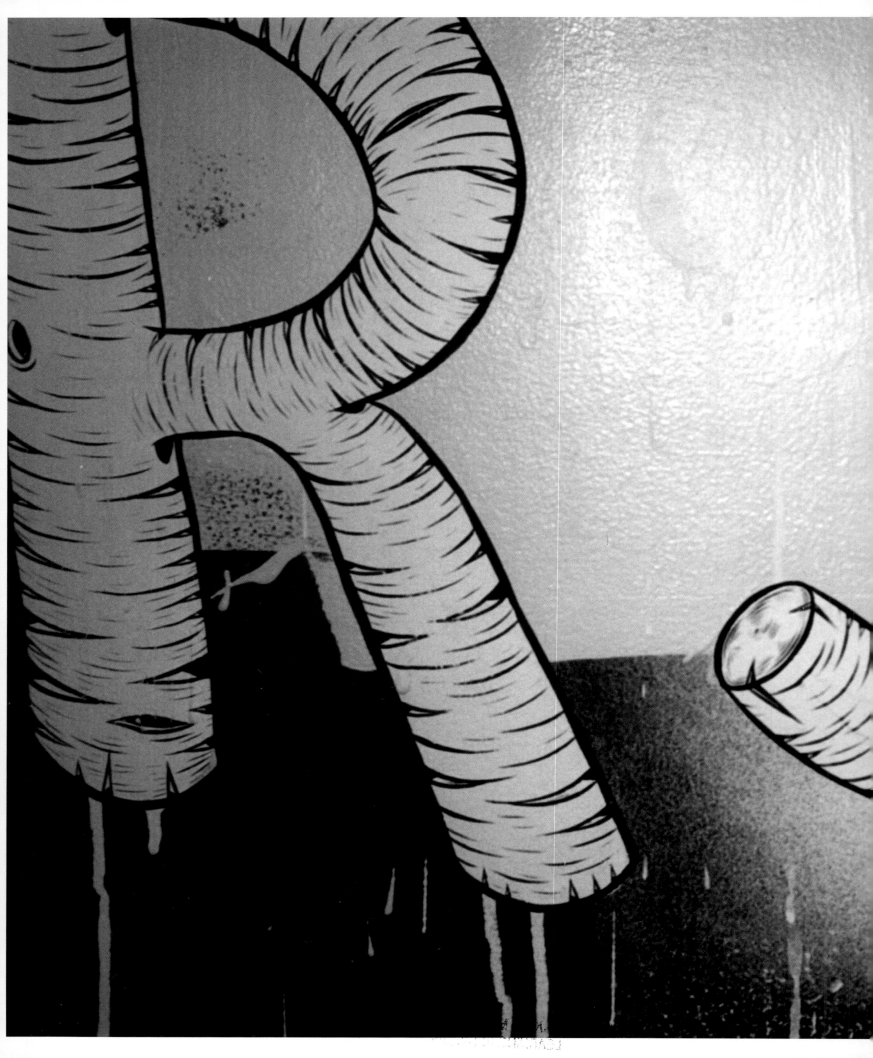

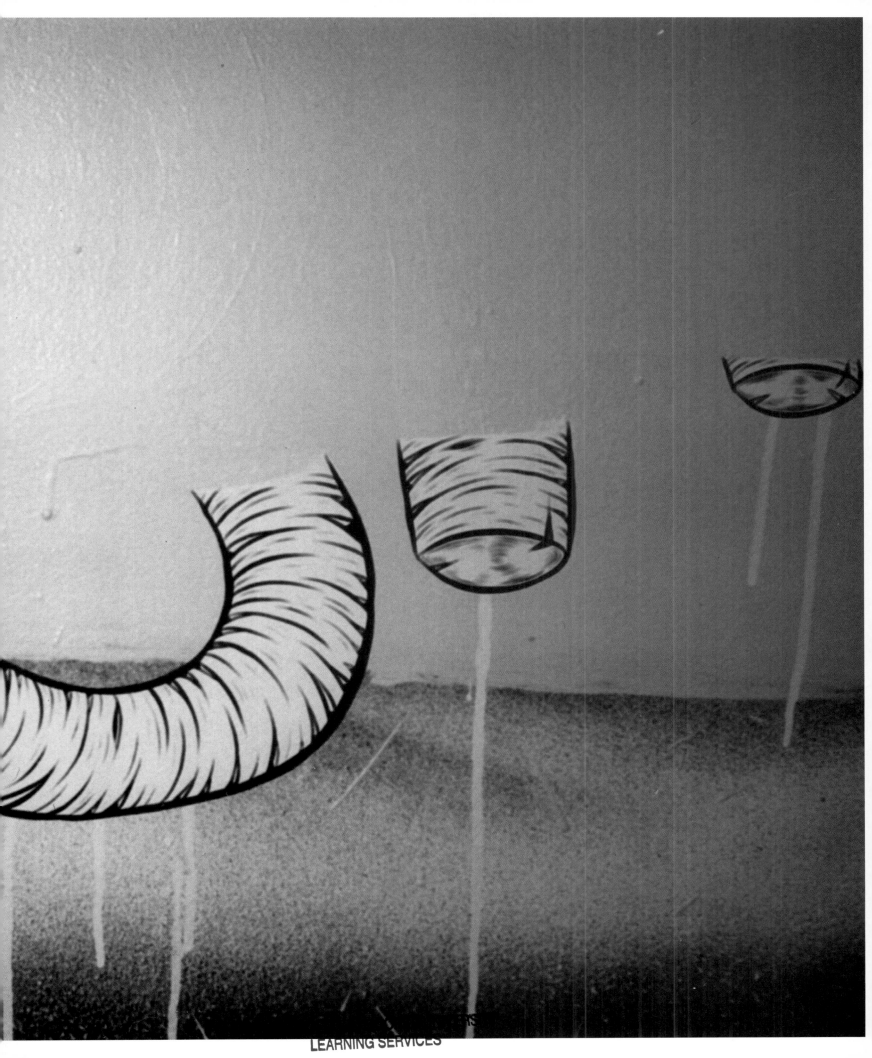

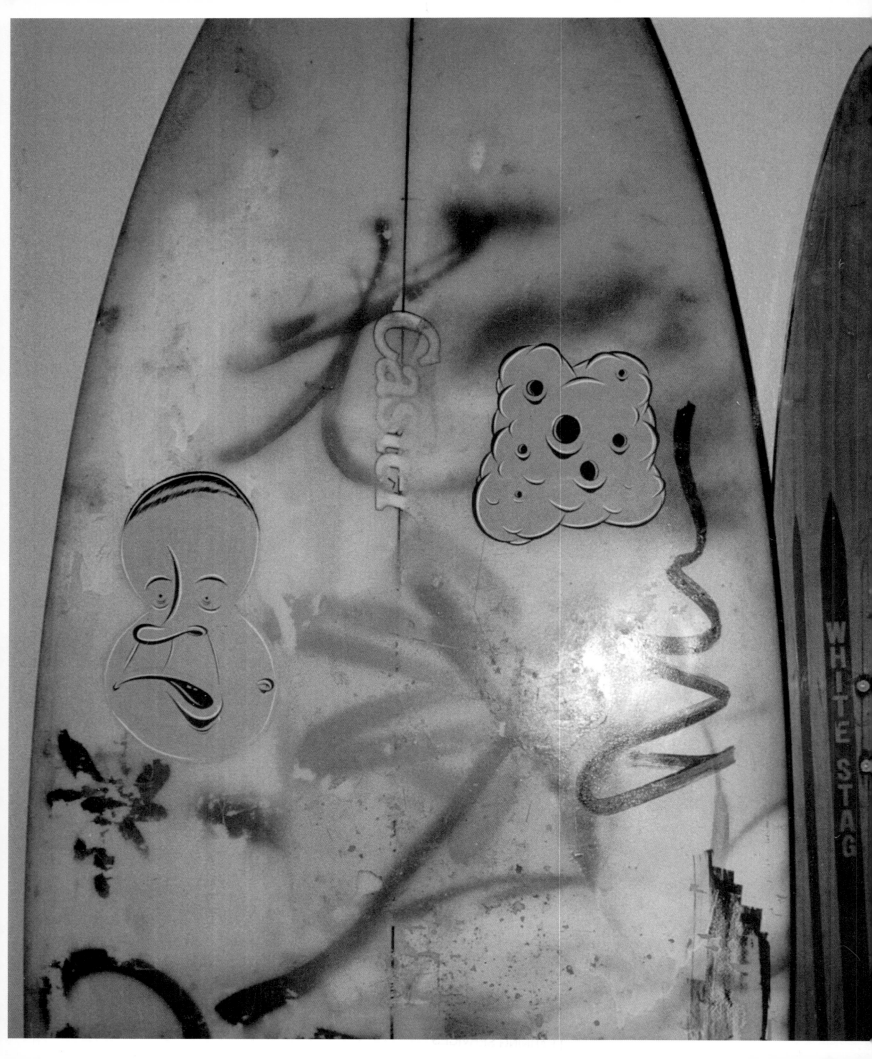

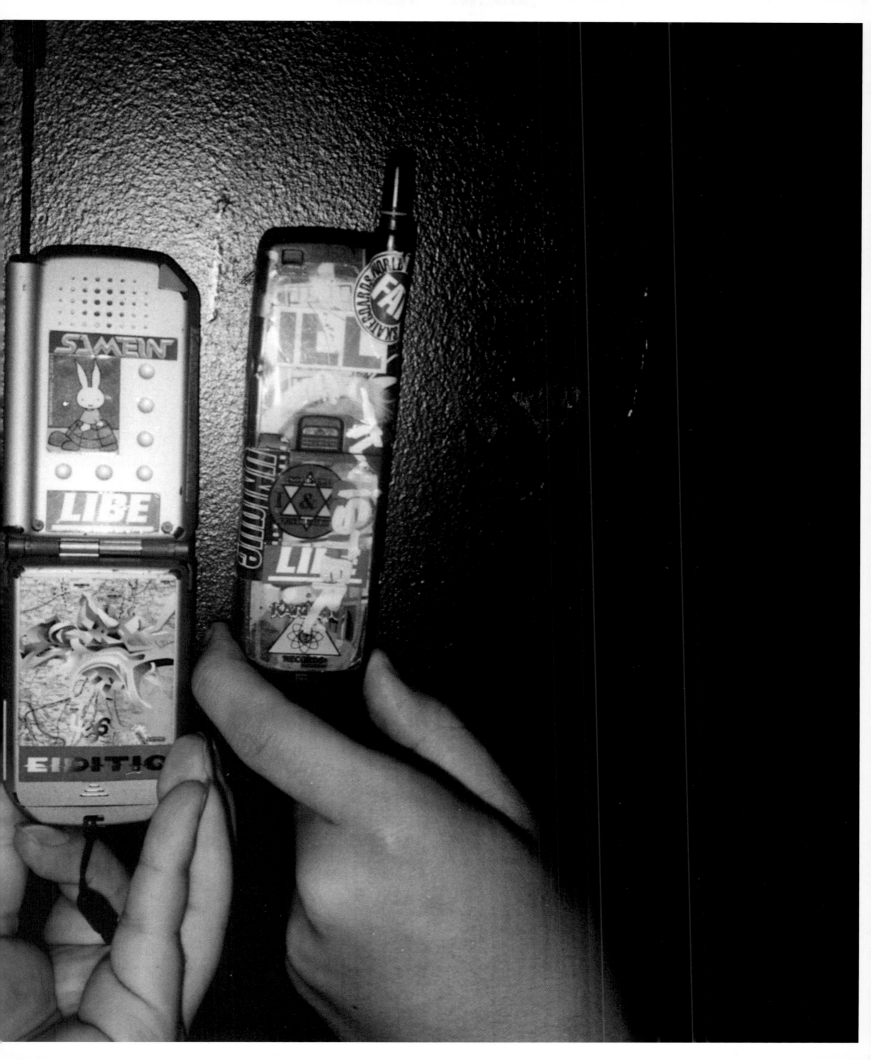

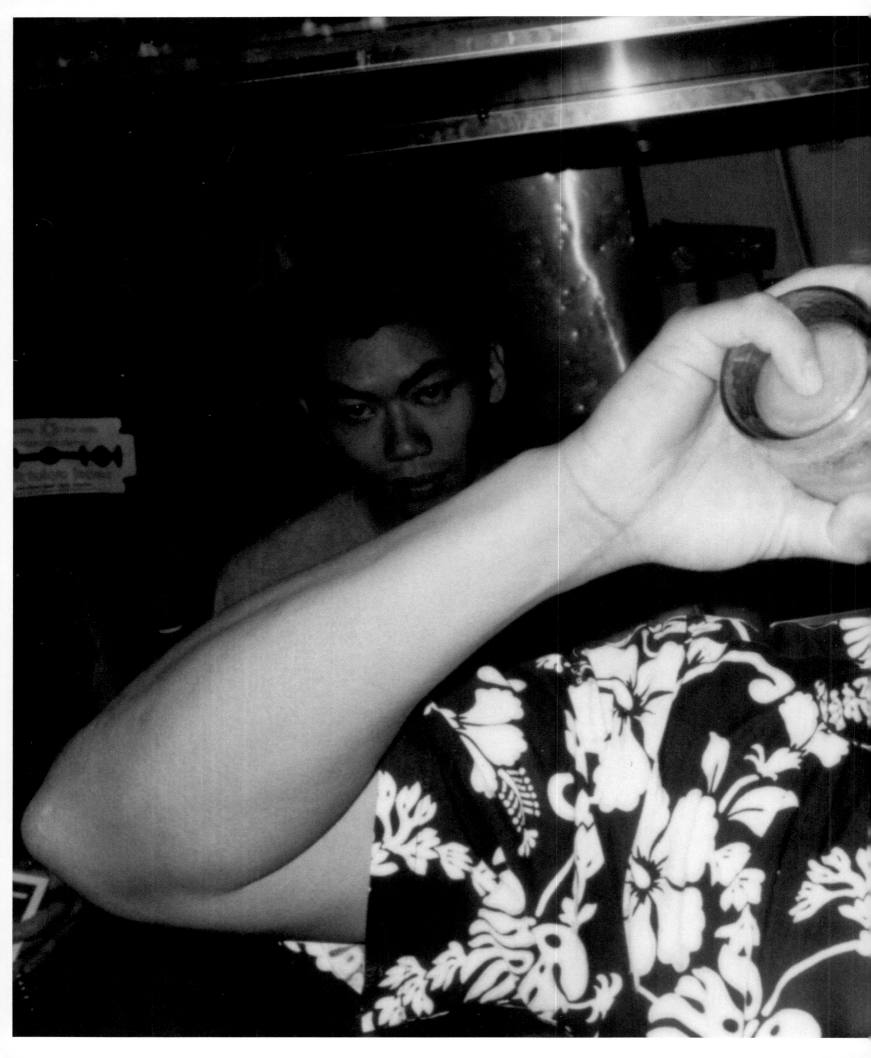

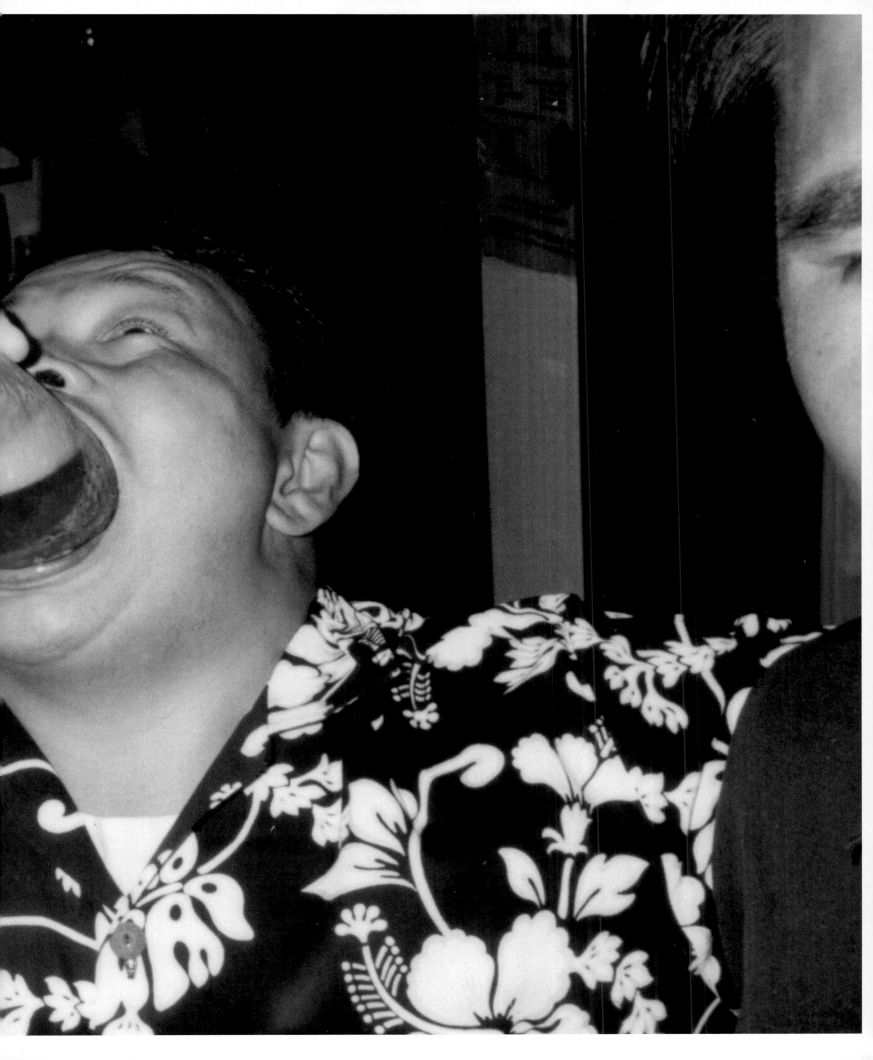

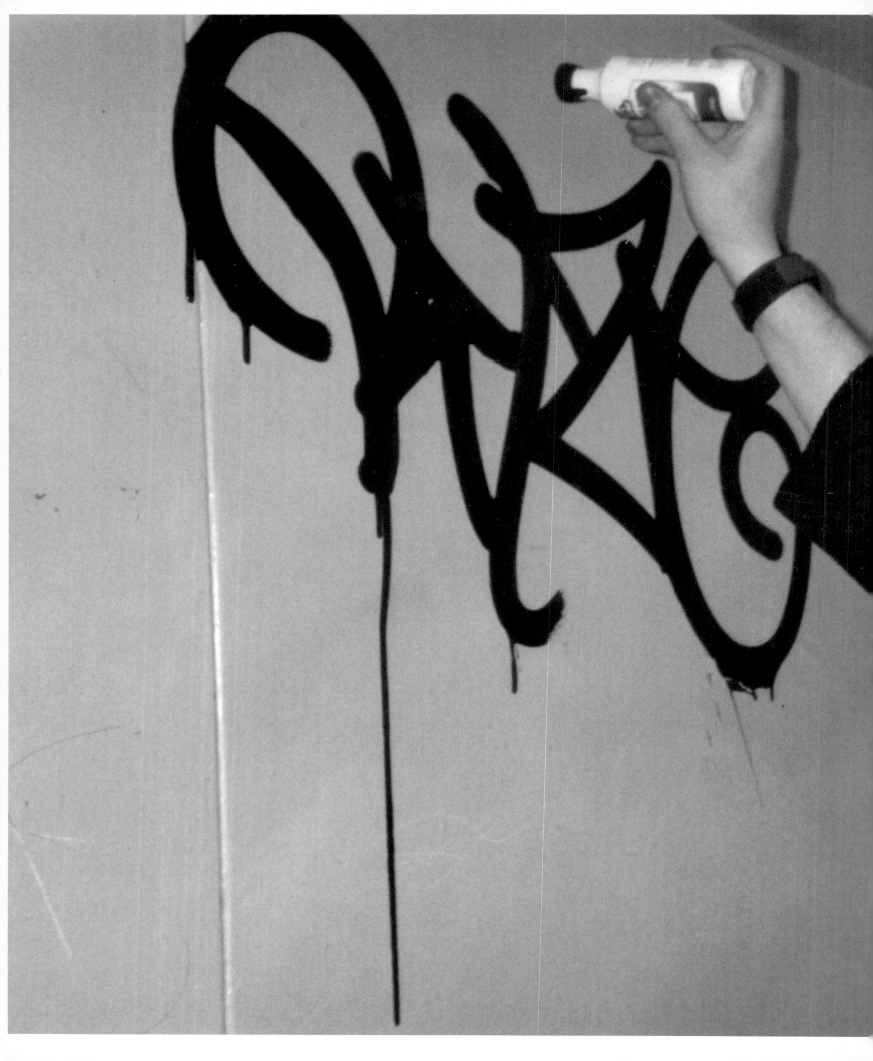

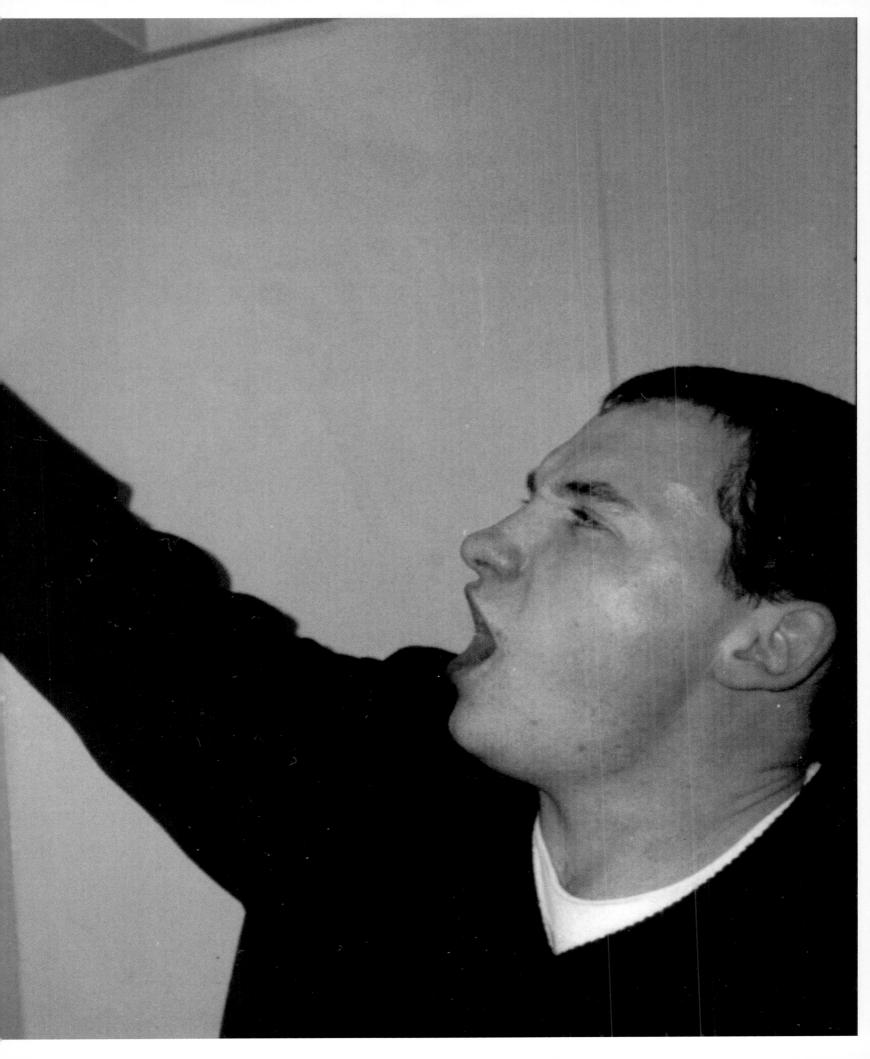

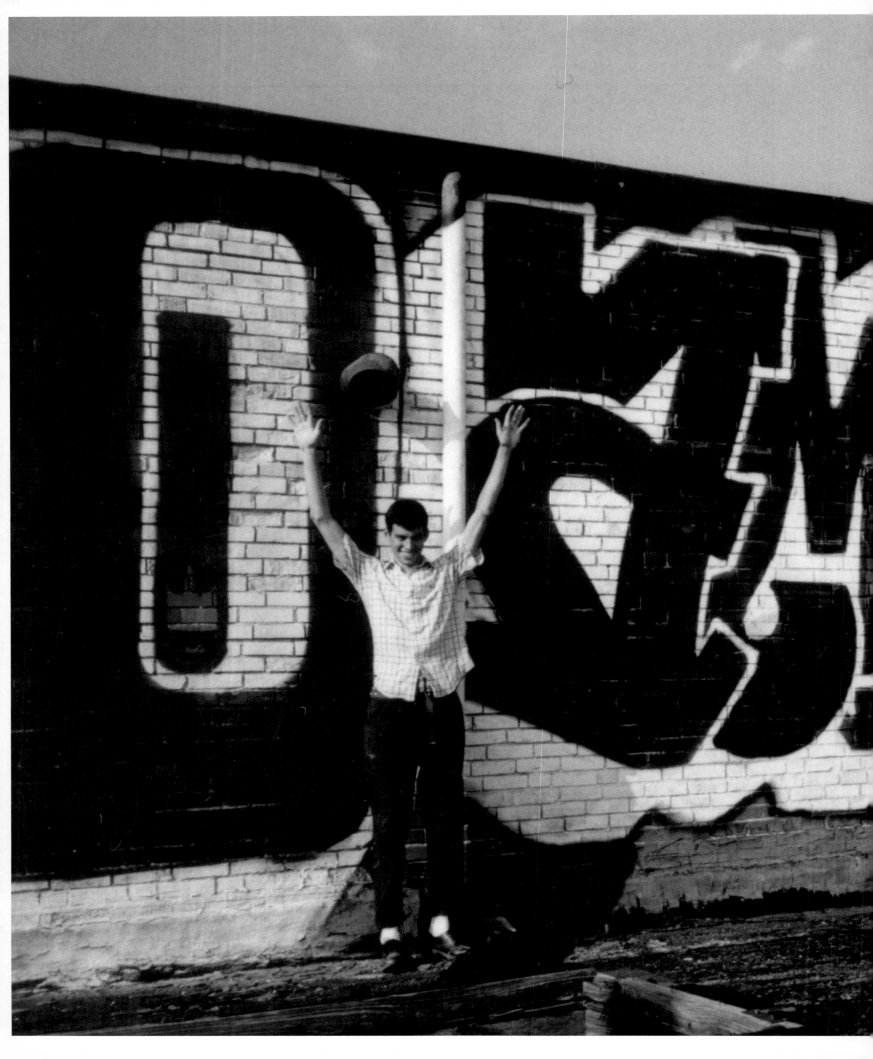

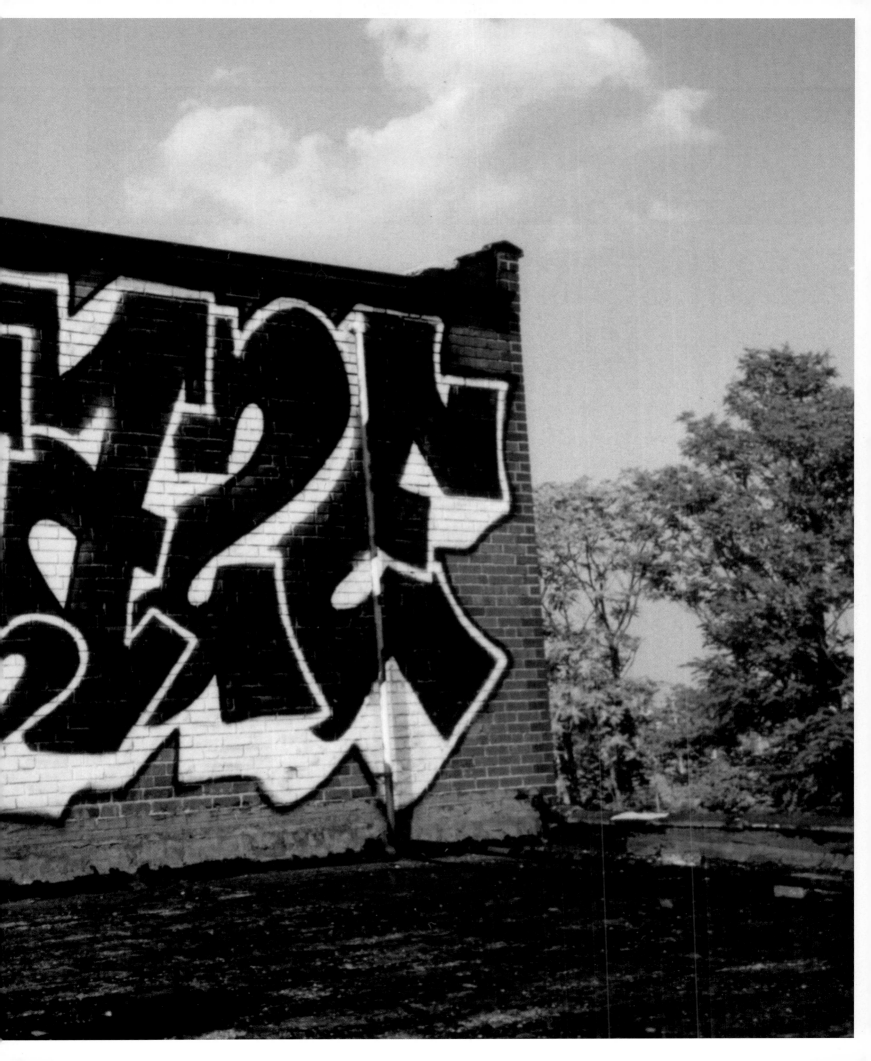

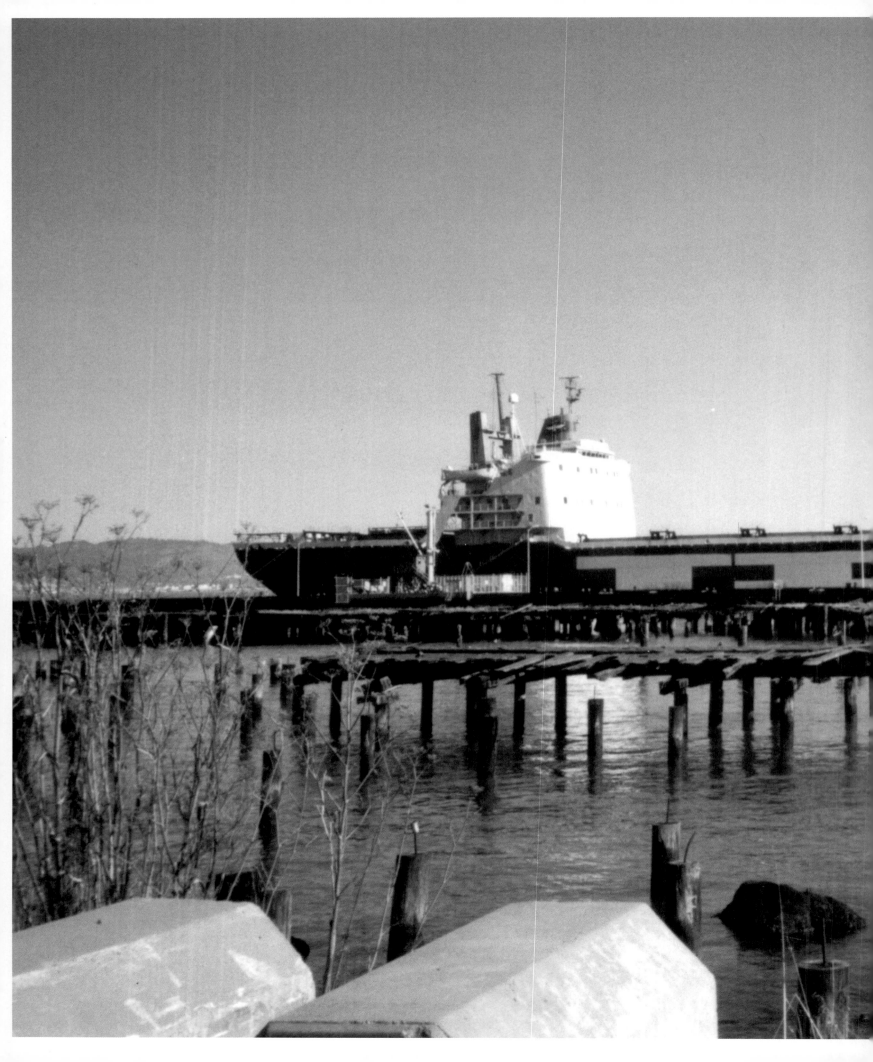

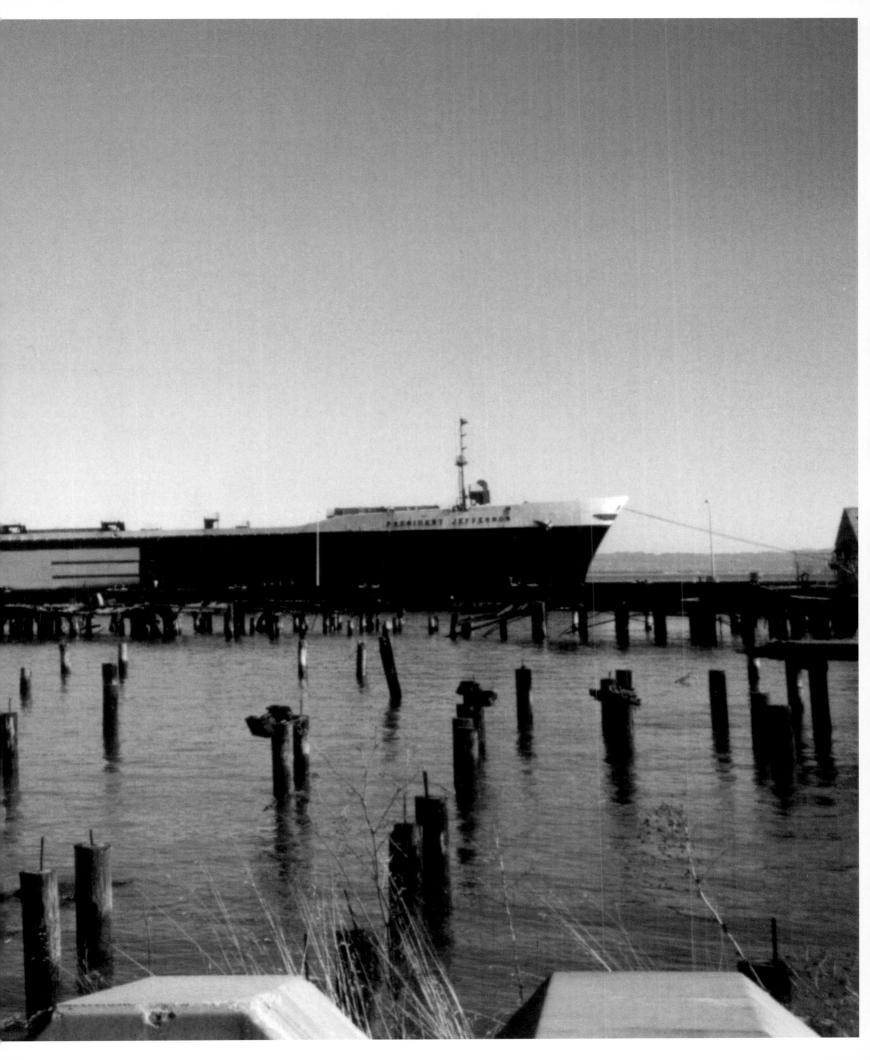

Love

Mere of

ran

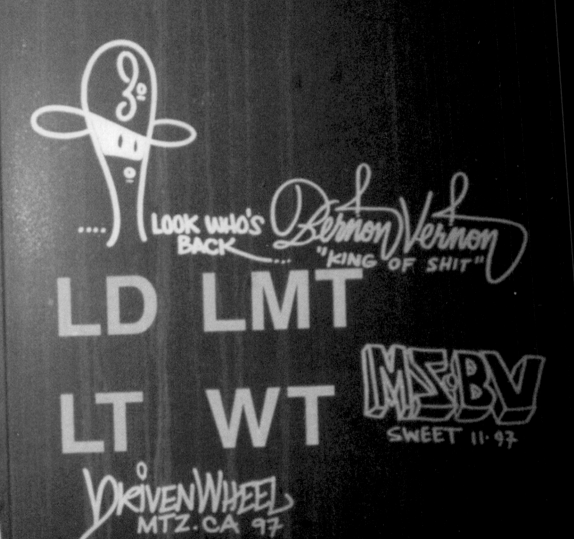

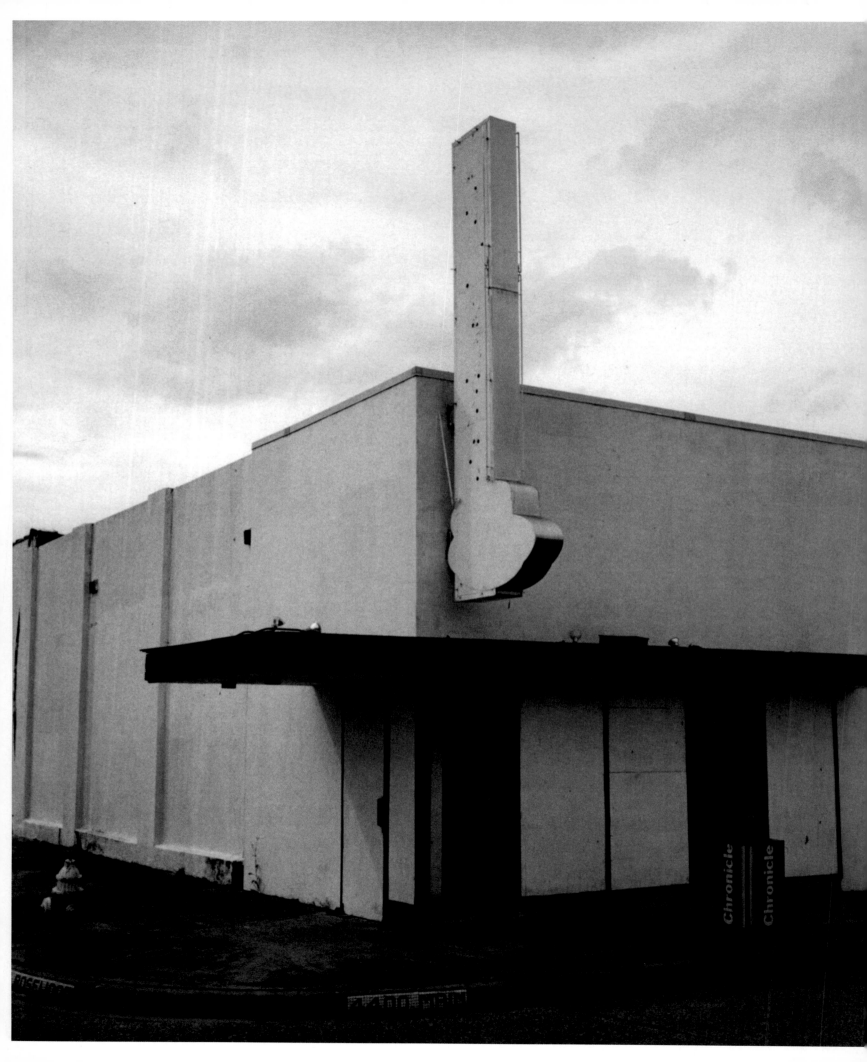

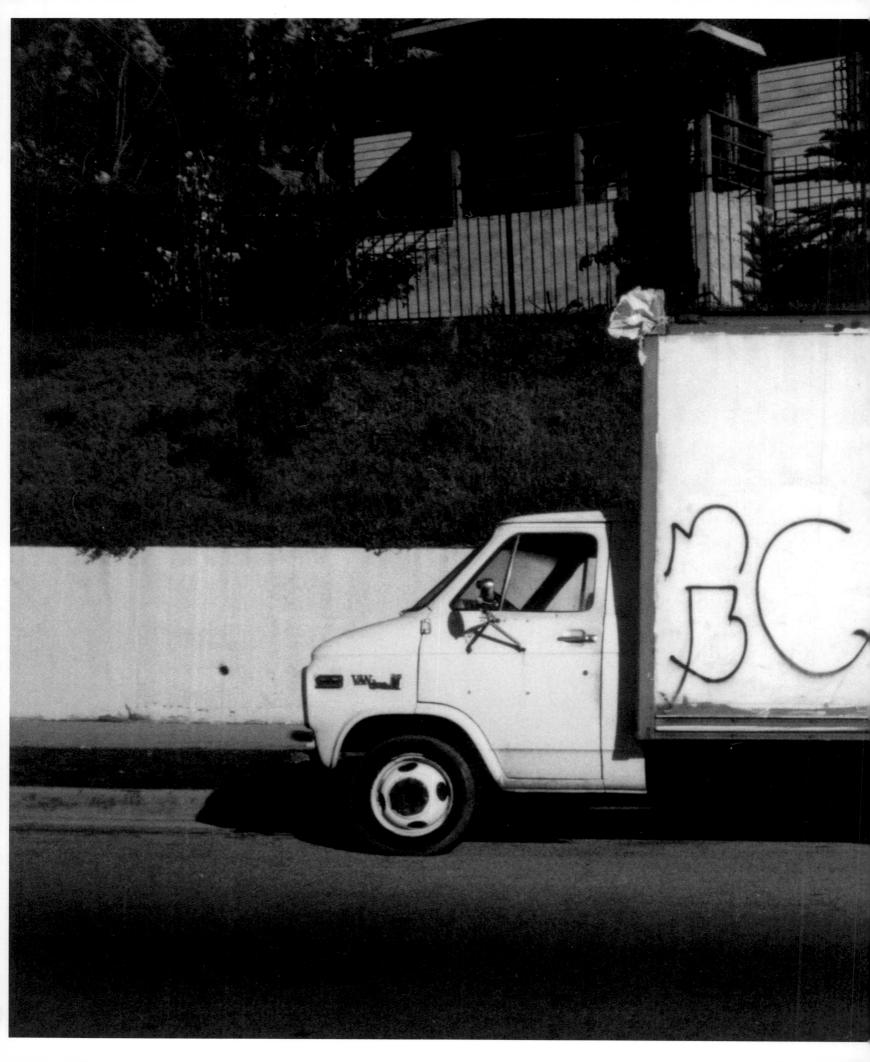

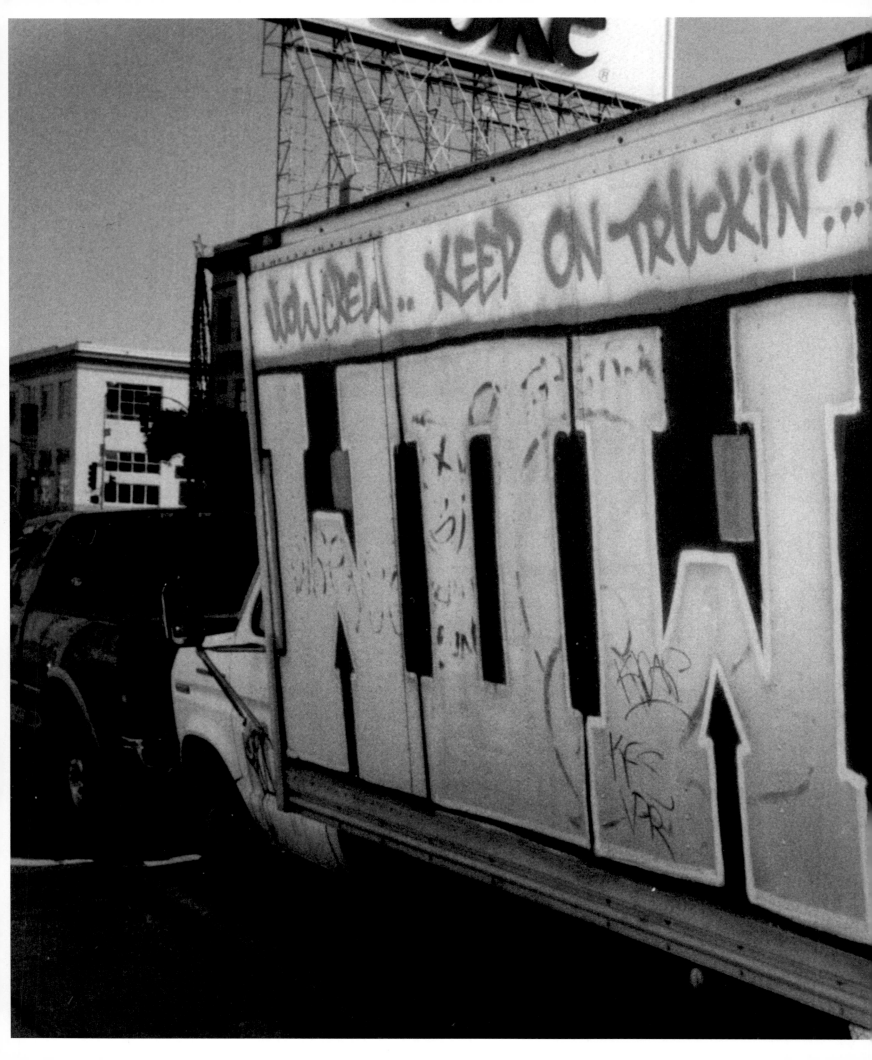

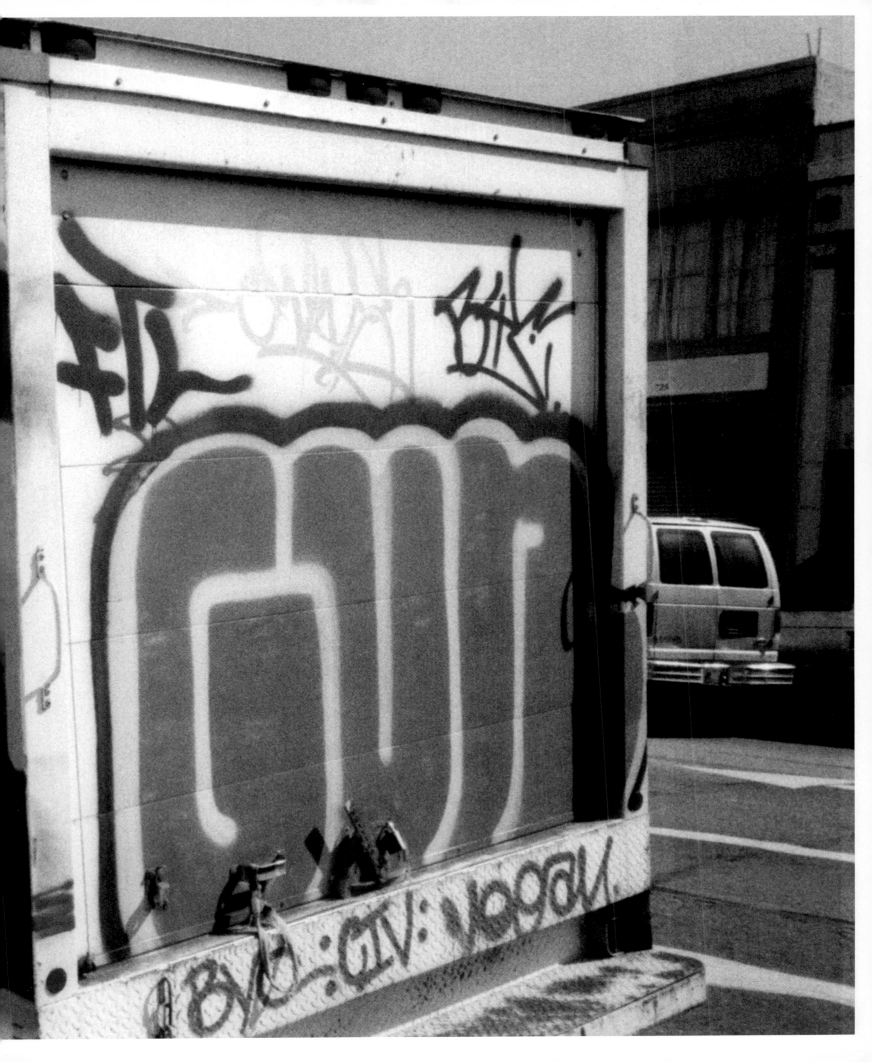

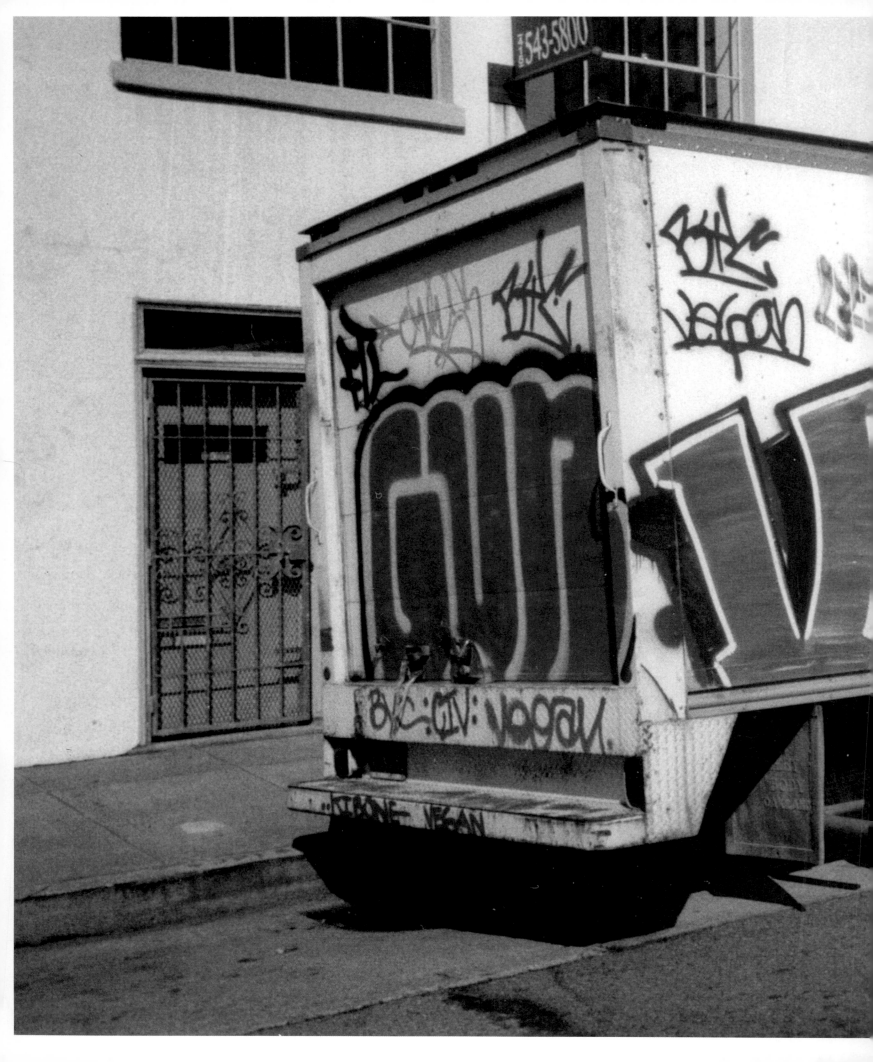

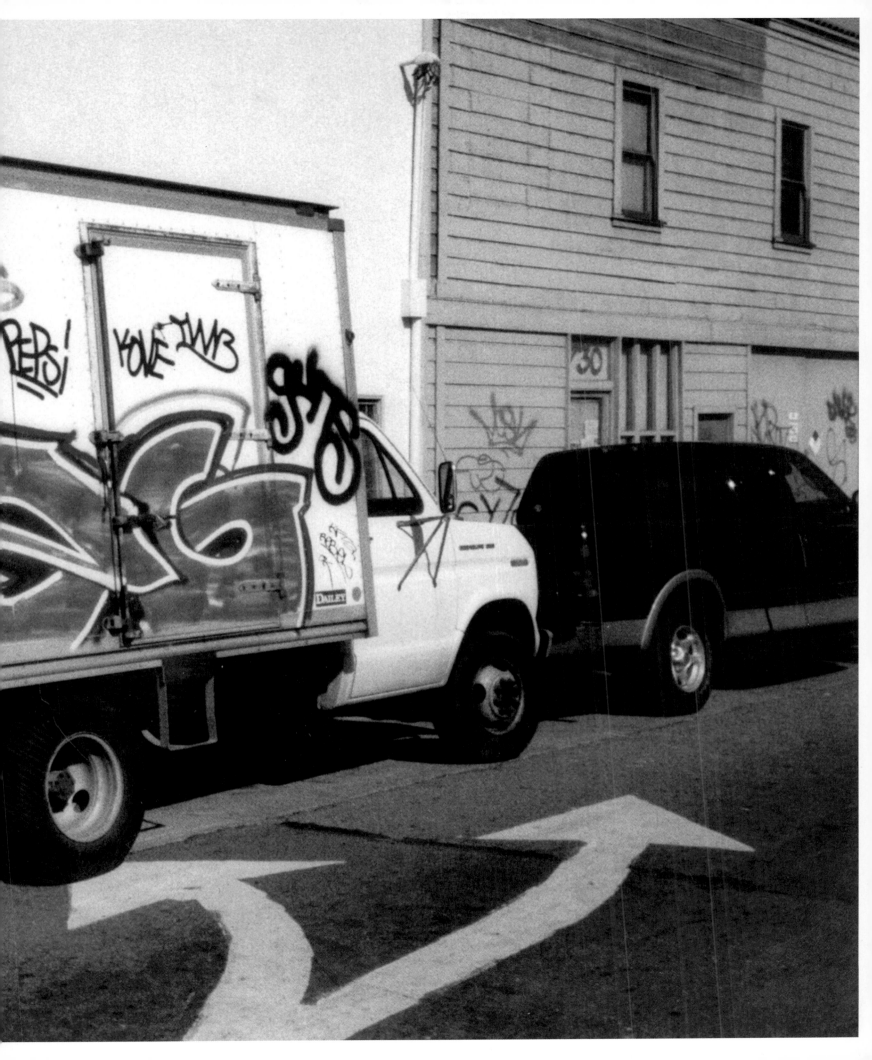

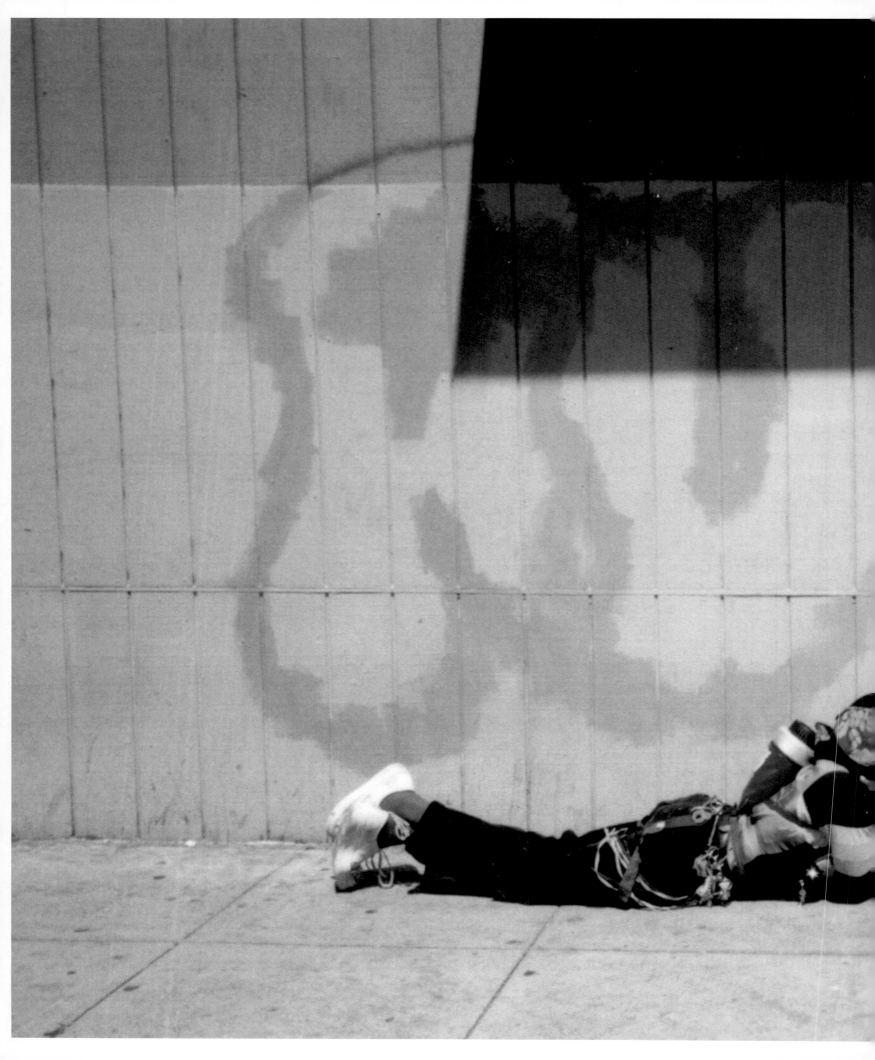

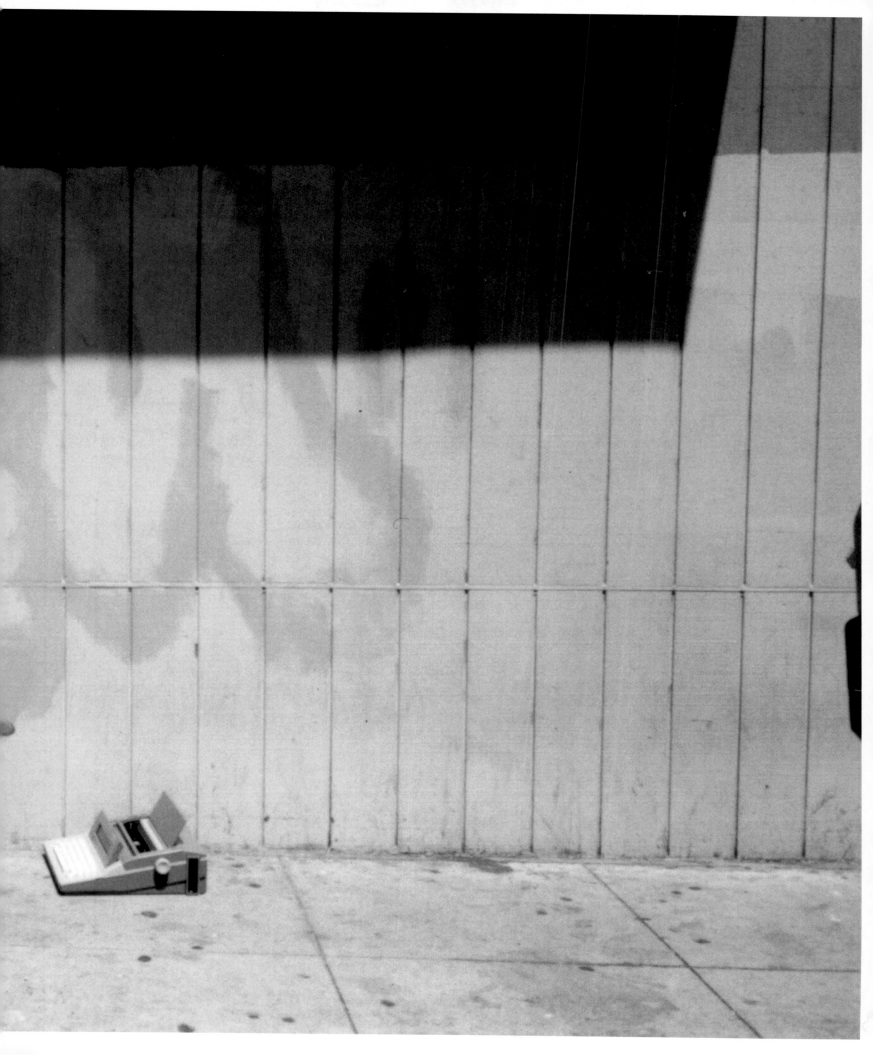

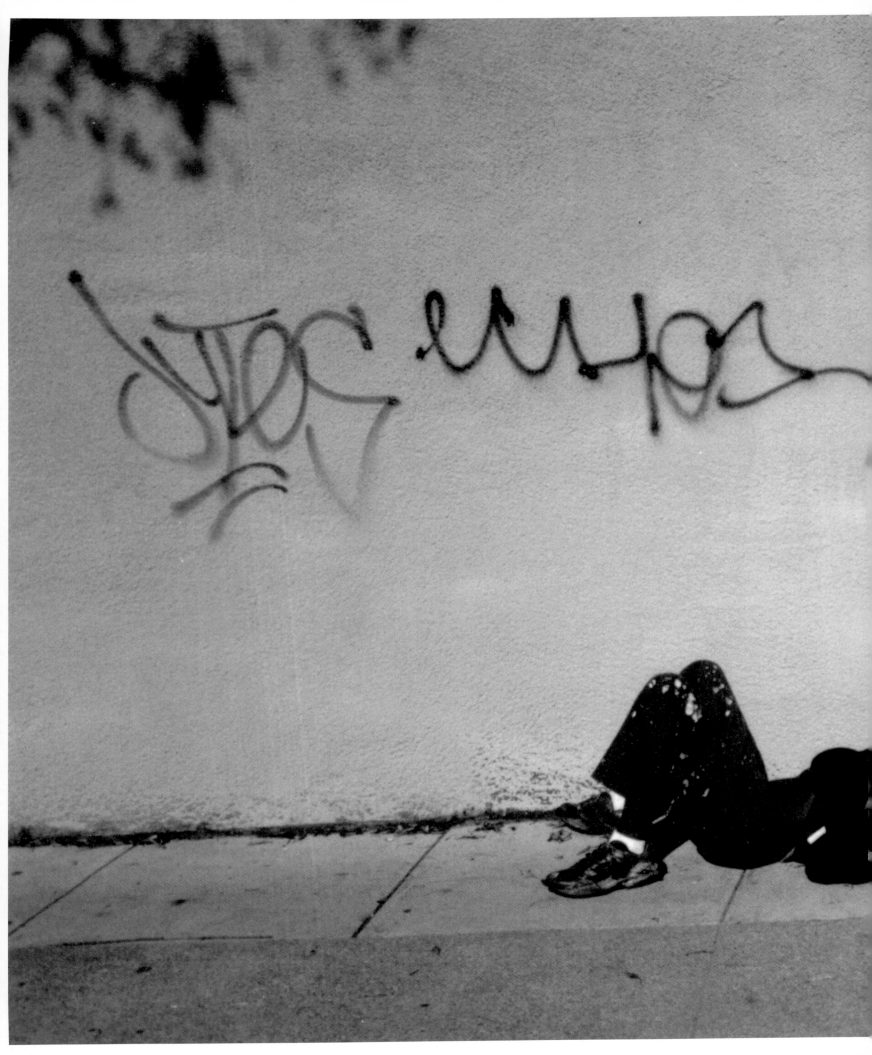

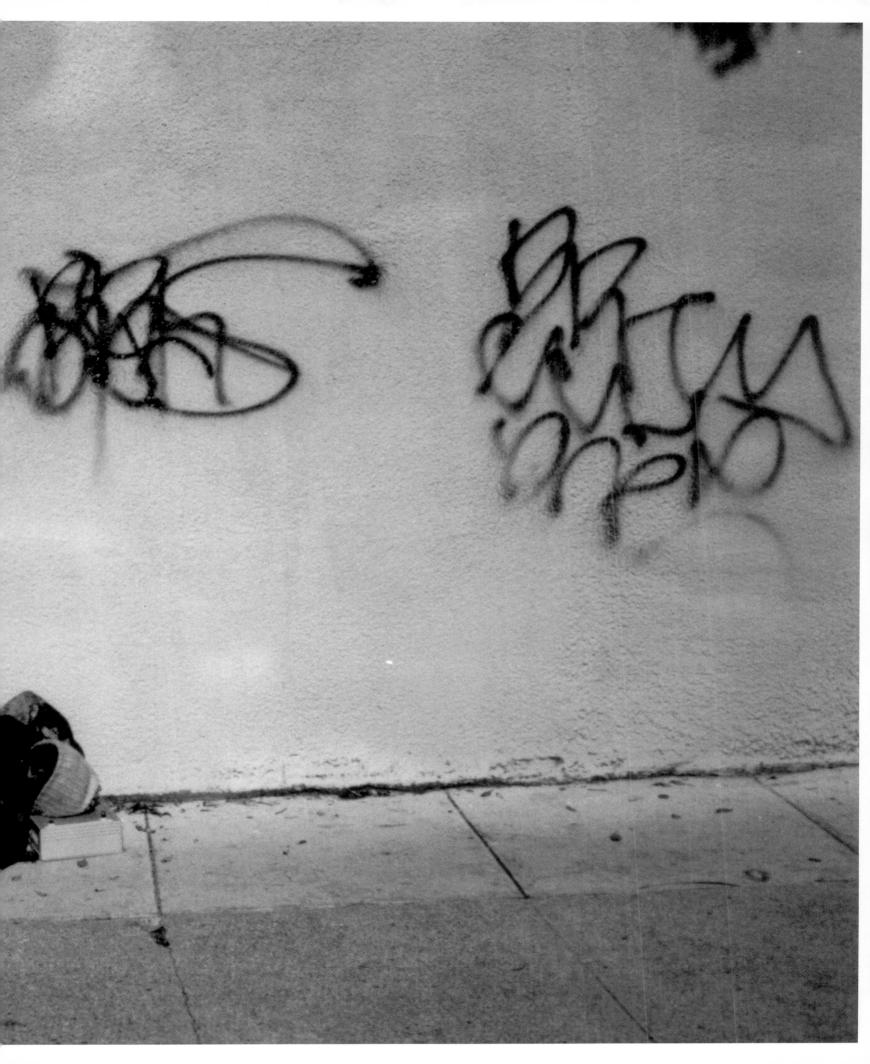

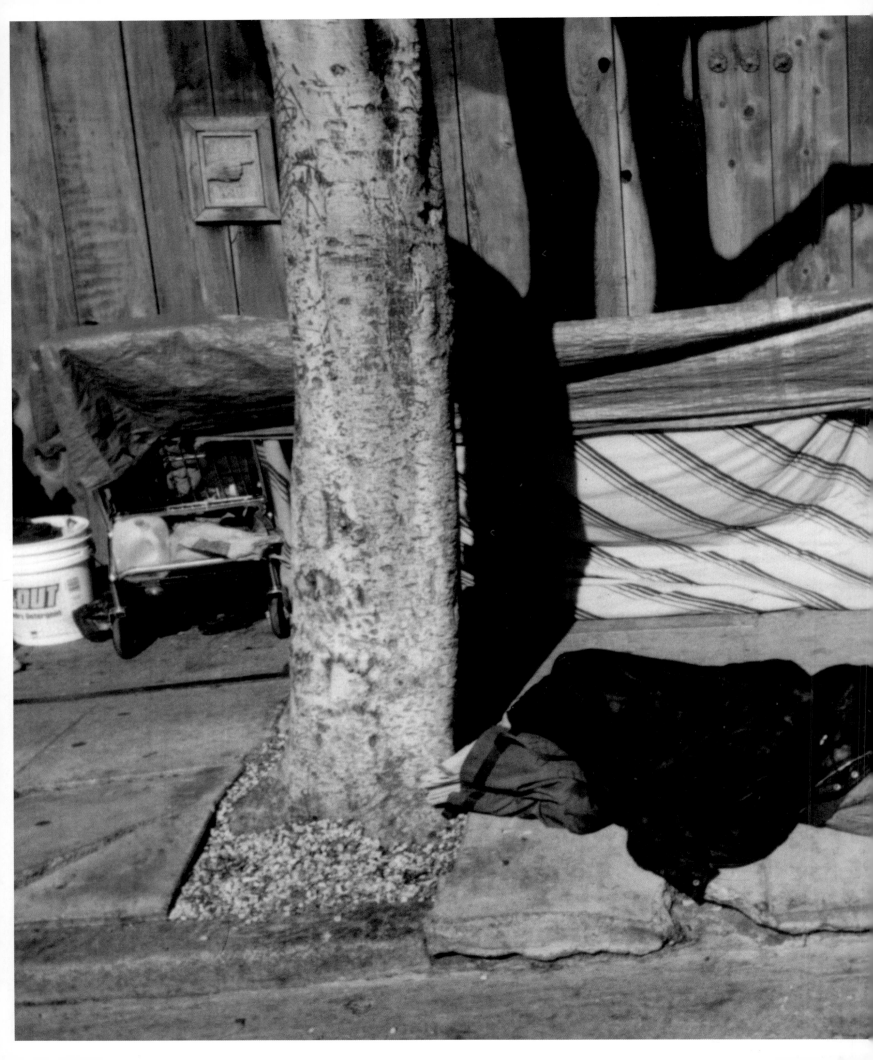

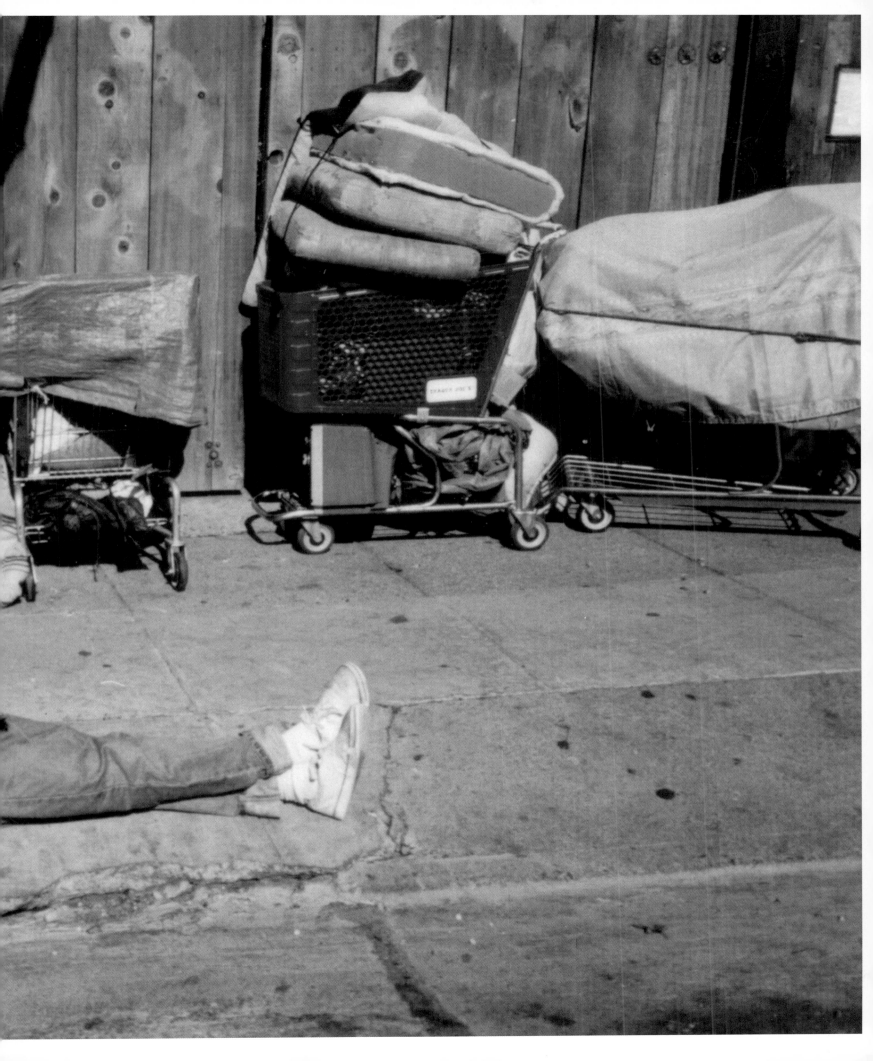

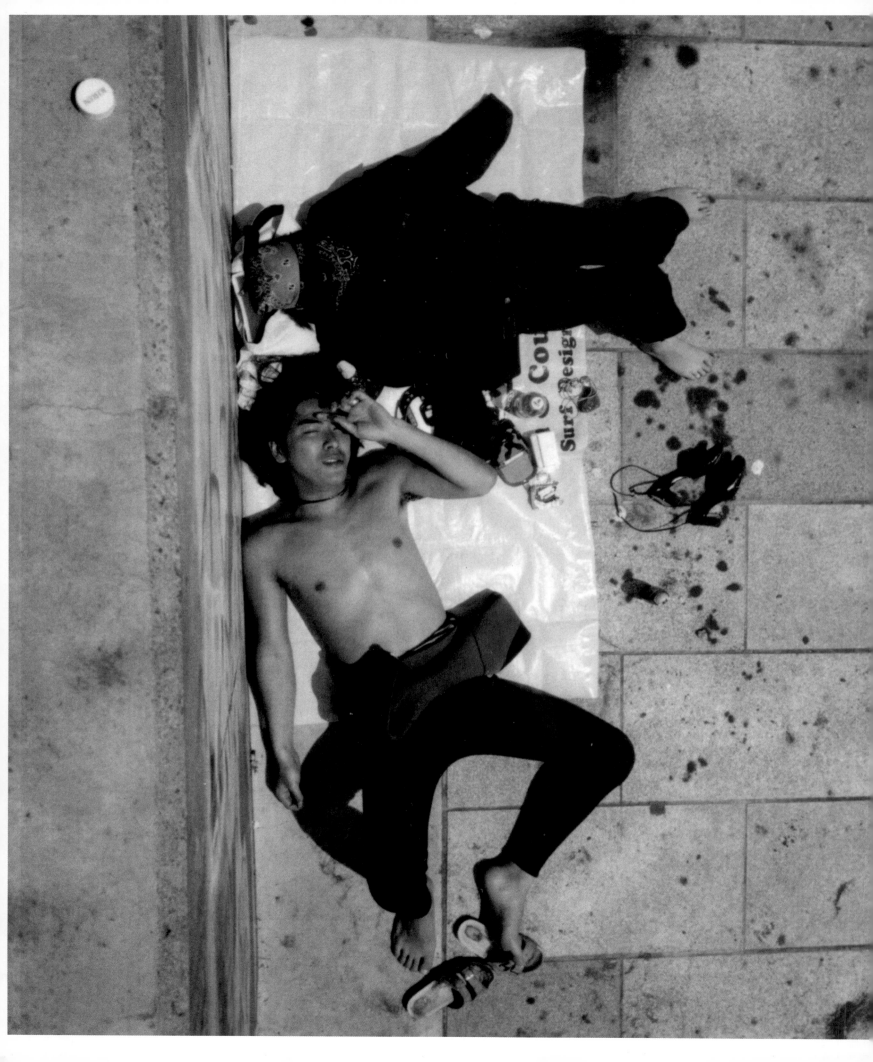

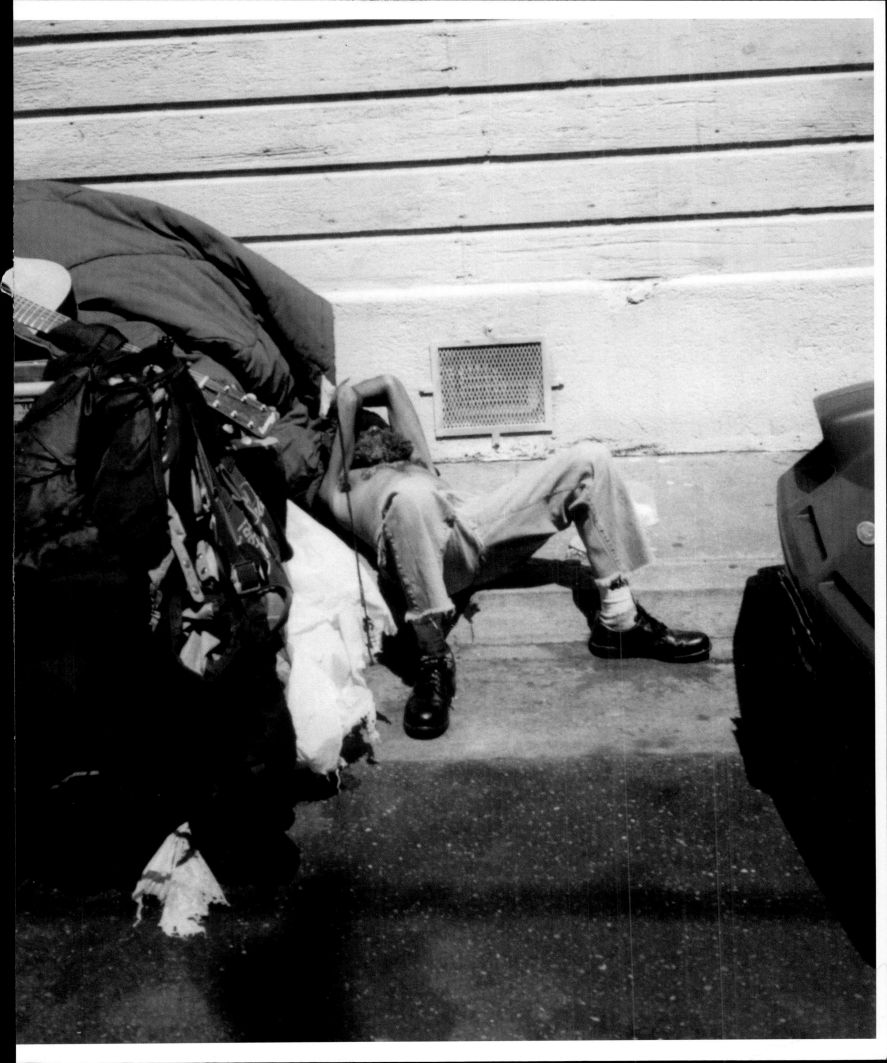

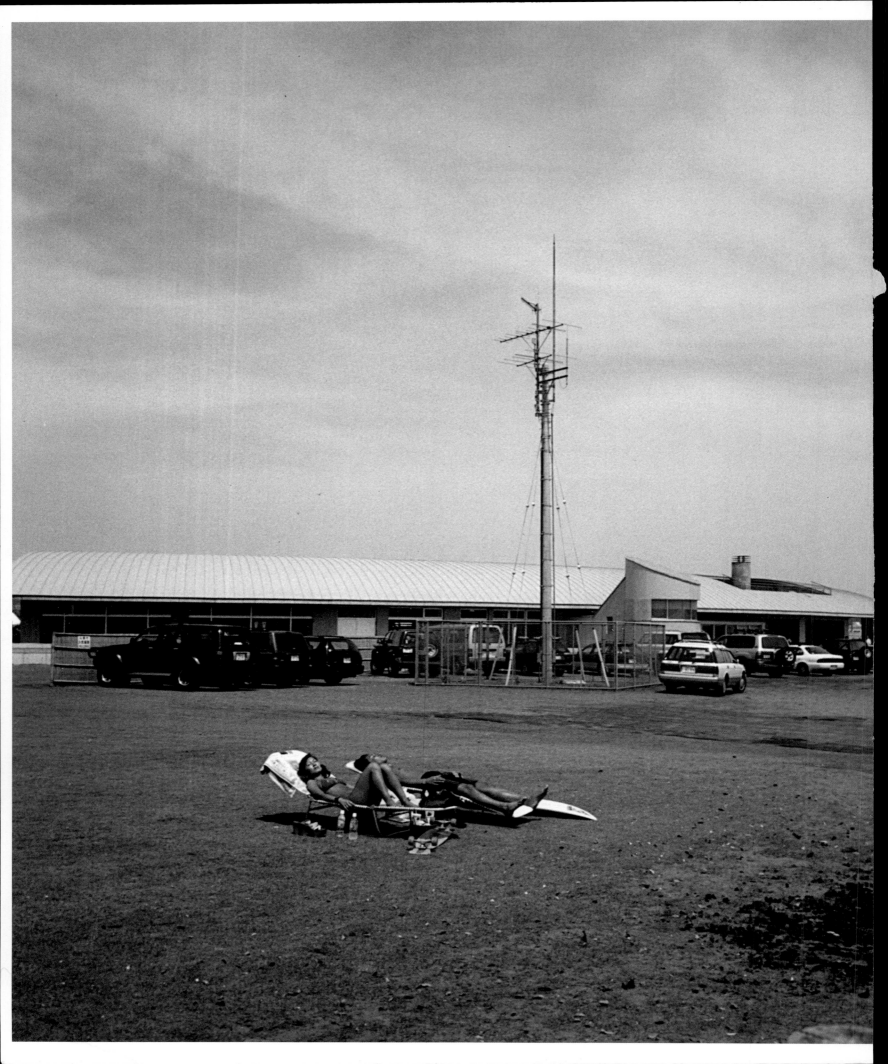

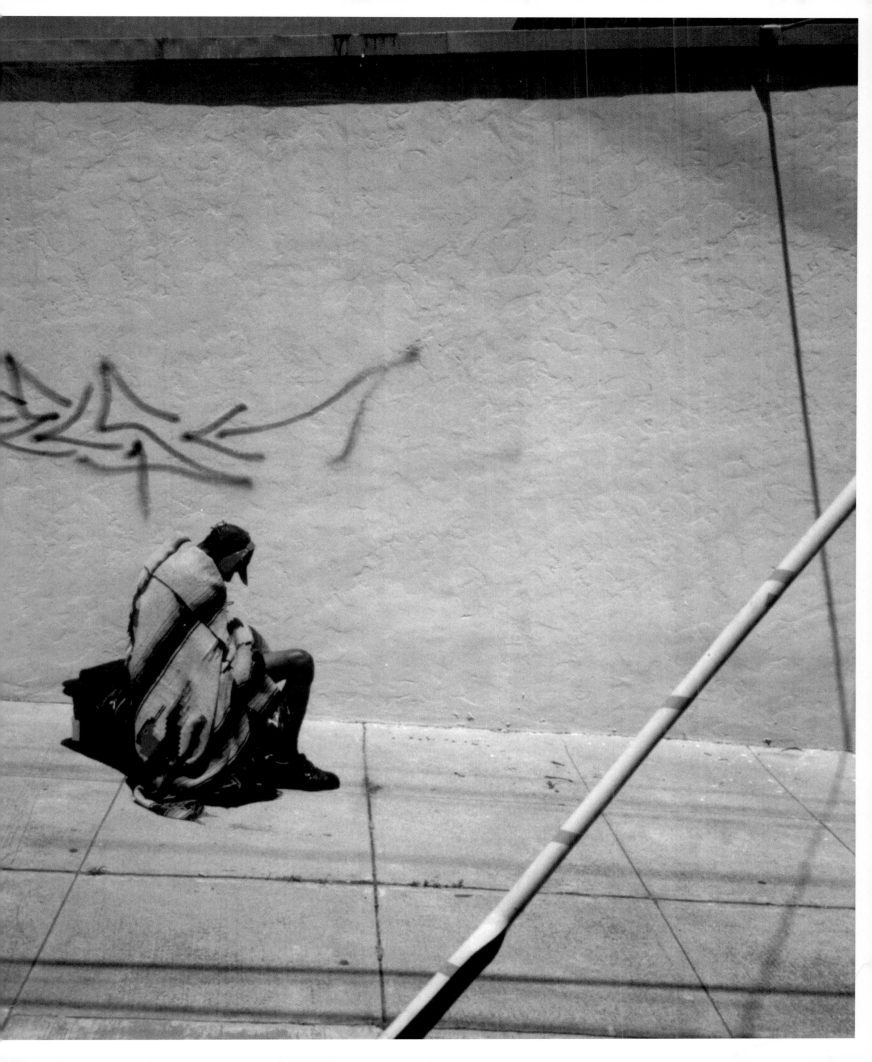

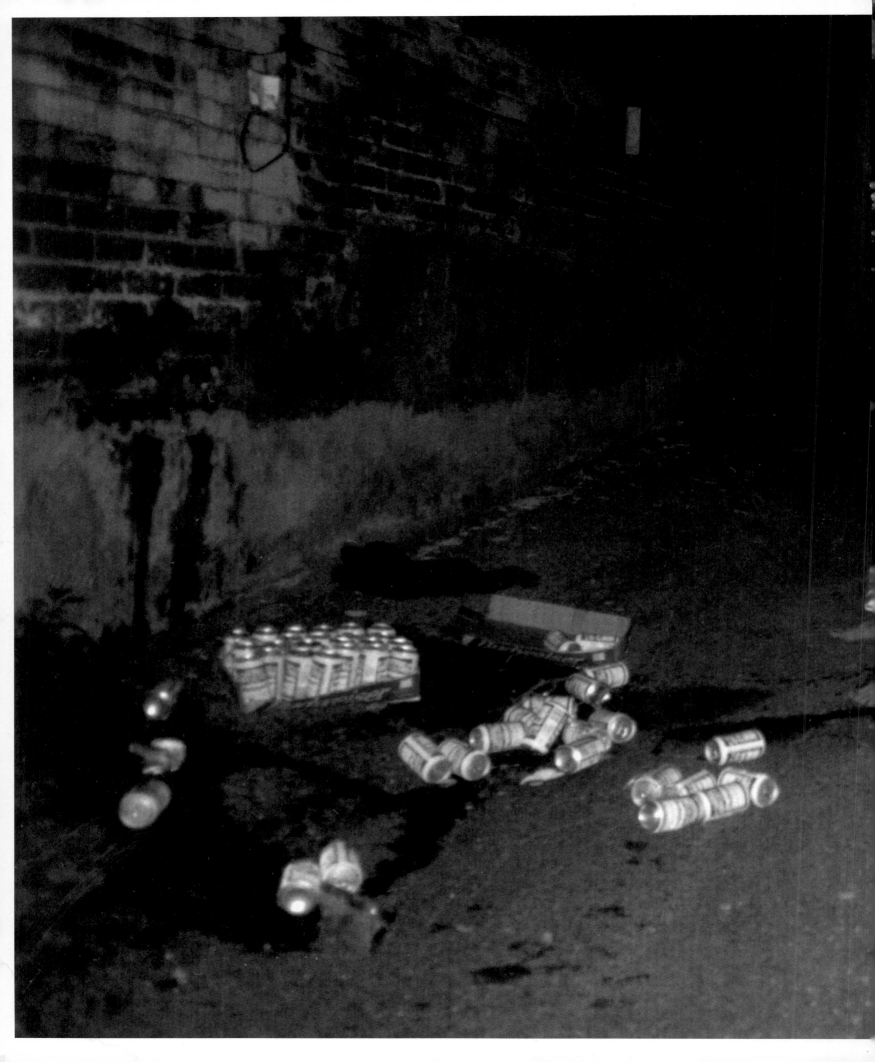

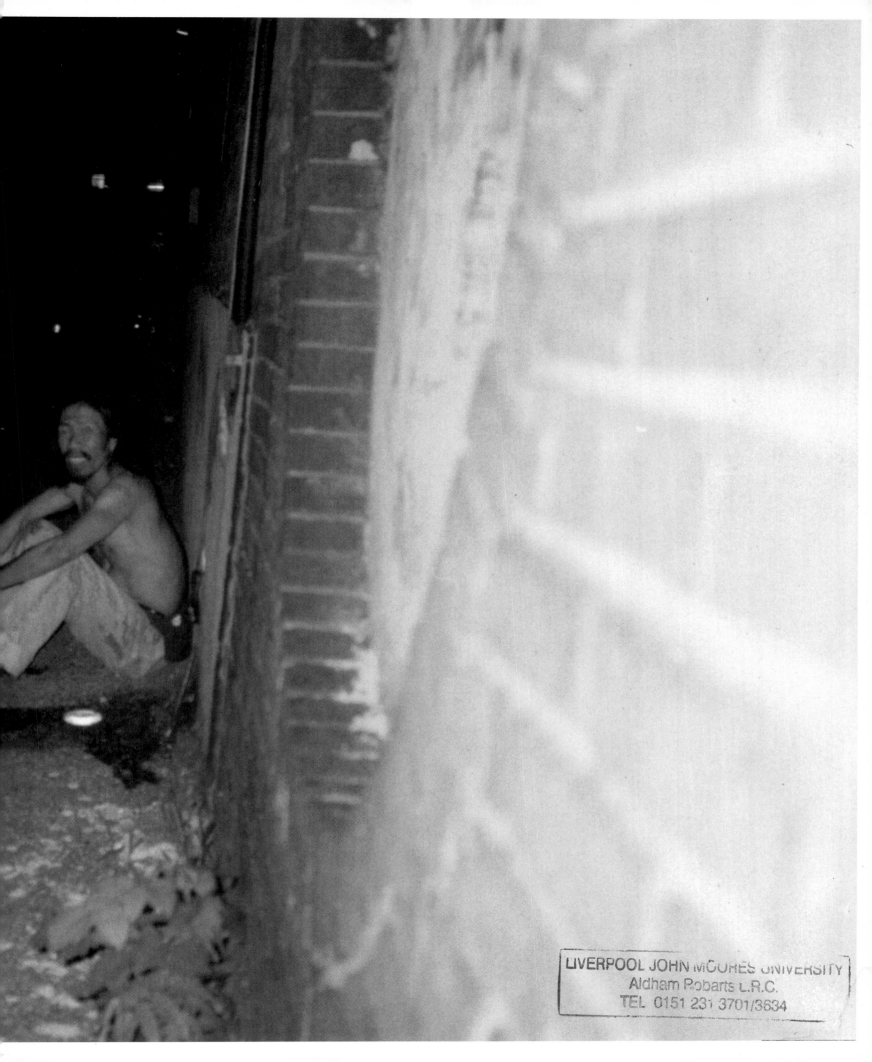

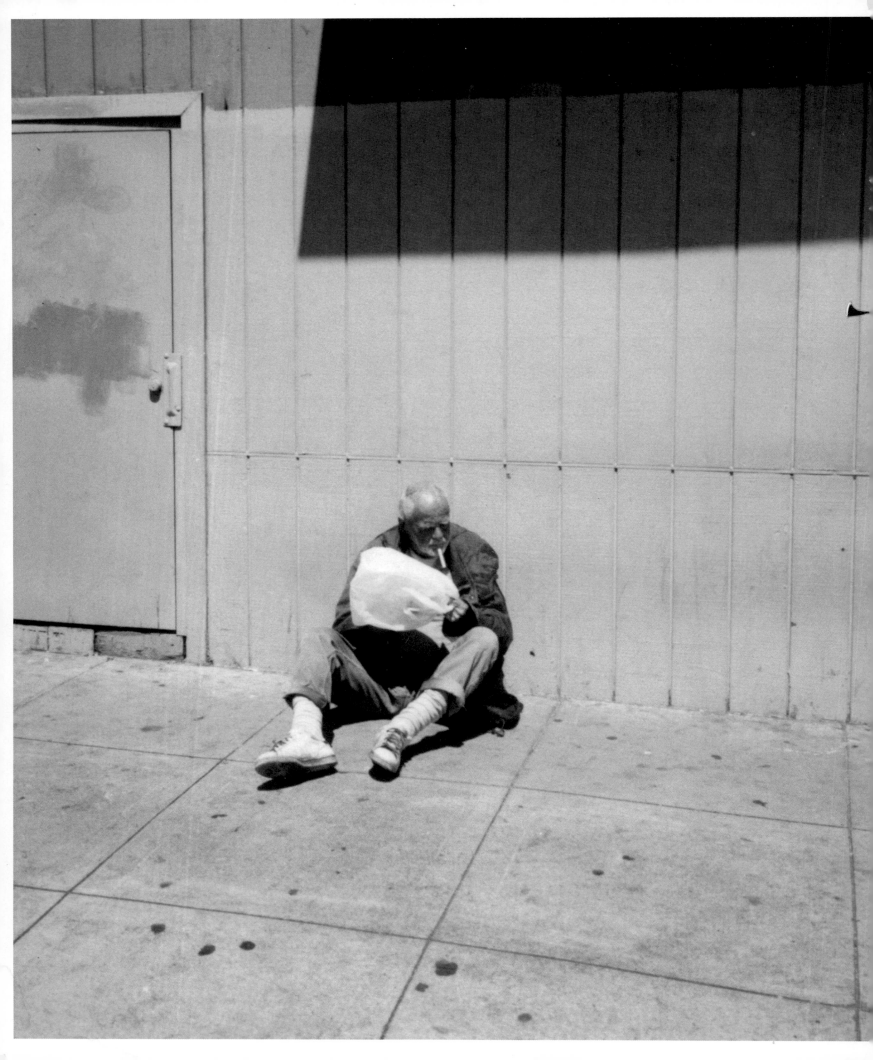